THE GRAND CANYON
AND THE SOUTHWEST

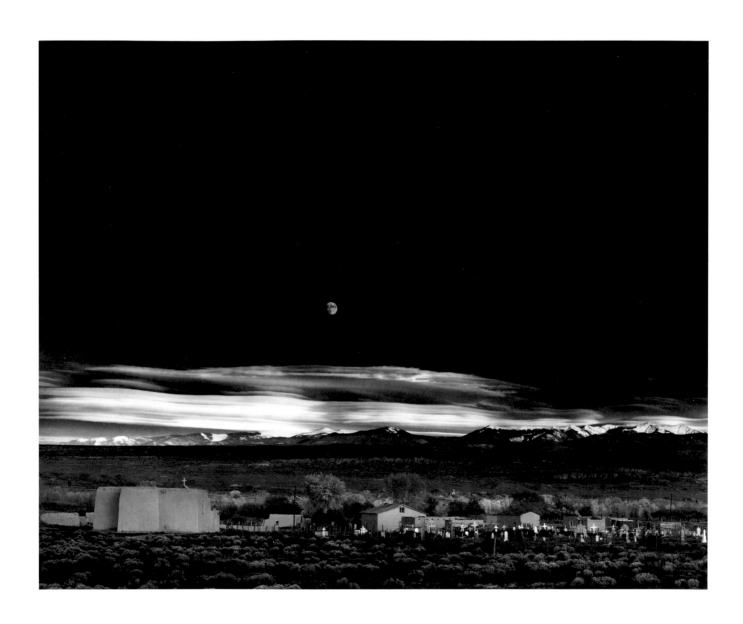

THE GRAND CANYON AND THE SOUTHWEST

ANSEL ADAMS

Edited by Andrea G. Stillman
Introduction by William A. Turnage

Little, Brown and Company

BOSTON · NEW YORK · LONDON

In 1976, Ansel Adams selected Little, Brown and Company as the sole authorized publisher of his books, calendars, and posters. At the same time, he established The Ansel Adams Publishing Rights Trust in order to ensure the continuity and quality of his legacy — both artistic and environmental.

As Ansel Adams himself wrote, "Perhaps the most important characteristic of my work is what may be called print quality. It is very important that the reproductions be as good as you can possibly get them." The authorized books, calendars, and posters published by Little, Brown have been rigorously supervised by the Trust to make certain that Adams' exacting standards of quality are maintained.

Only such works published by Little, Brown and Company can be considered authentic representations of the genius of Ansel Adams.

Acknowledgments

I would like to thank the many people who helped in the preparation of this book: Dean Bornstein, Janet Swan Bush, Carolyn Cooper, Jessica Calzada Jablonski, Patrick Jablonski, Sandra Klimt, Melissa Langen, Betty Power, Merriam Saunders, Martin Senn; Leslie Calmes, Dianne Nilsen, and Marcia Tiede of the Center for Creative Photography; Laura Daroca, The Huntington Library; Karen E. Haas, The Lane Collection, Boston Museum of Fine Arts; Virginia Heckert, Newhall Fellow, Musuem of Modern Art; Del Zogg, George Eastman House; and the Trustees of The Ansel Adams Publishing Rights Trust: John P. Schaefer, William A. Turnage, and David H. Vena.

— A. G. S.

First Edition

Library of Congress Cataloging-in-Publication Data

Adams, Ansel.
 The Grand Canyon and the Southwest / Ansel Adams; edited by Andrea G. Stillman and with an introduction by William A. Turnage.
 p. cm.
 ISBN 0-8212-2650-9 (pbk.)
 1. Adams, Ansel, 1902–1984. 2. Grand Canyon (Ariz.) — Pictorial works. 3. Southwest, New — Pictorial works. 4. Landscape photography — Arizona — Grand Canyon. 5. Landscape photography — Southwest, New. I. Stillman, Andrea Gray. II. Title.

F788 .A33 2000
779'.3673'092 — dc21

Frontispiece: *Moonrise, Hernandez, New Mexico, 1941*

Designed by Dean Bornstein
Digital photography and duotone separations by Martin Senn
Printed by Stamperia Valdonega

PRINTED IN ITALY

An Introduction

Ansel Adams. The Grand Canyon. The Southwest. They go together very well indeed. It is true, of course, that most of us think of Yosemite and the High Sierra when we think of Ansel. But, in actual fact, he had yet another "home place," another great love. It lay in the magnificent deserts and luminous mountains — the Spanish towns and Indian pueblos — of the American Southwest. Santa Fe and Taos. The Sangre de Christo Mountains. Big Bend National Park. The Grand Canyon of the Colorado. Monument Valley and Canyon de Chelly. Death Valley and Joshua Tree. Mission San Xavier del Bac. The ancient pueblos of Acoma, Laguna, and San Ildefonso. Mesa Verde National Park. Zion and Cedar Breaks. The Ghost Ranch and the Enchanted Mesa. These were his special places. He wrote, in a 1937 letter to Alfred Stieglitz,

It is all very beautiful and magical here — a quality which cannot be described. You have to live it and breathe it, let the sun bake it into you. The skies and the land are so enormous, and the detail so precise and exquisite that wherever you are you are isolated in a glowing world between the macro and the micro, where everything is sidewise under you and over you, and the clocks stopped long ago.

The decisive, formative years of Ansel's artistic life — from 1927 to 1931 — were profoundly altered and influenced by the people and places of northern New Mexico. Over more than fifty years, on literally dozens of trips, he traveled innumerable miles to and through the Southwest. He created five books on the region, including his first, *Taos Pueblo,* and, in 1976, one of his favorites, *Photographs of the Southwest.* The legendary *Moonrise, Hernandez, New Mexico* (1941) is, beyond doubt, his most famous photograph — and one of the best-known images of the century. He did some of his most successful photojournalistic and commercial projects in the region. His archive was established at the University of Arizona in Tucson. Appropriately, he bought his first Stetson — the western hat that was to become his ubiquitous trademark — for $6, on a 1929 trip to New Mexico.

Ansel had trained, with infinite rigor, to be a concert pianist and, until he was twenty-five, had intended to make the piano his career. Photography, at first a hobby and increasingly a passion, had primarily been pursued in Yosemite and the High Sierra. It is difficult to be certain when the decision for photography began to dominate. On the other hand, it is absolutely clear that his early experiences in the Southwest played a — if not *the* — critical role in his remarkably rapid emergence, in the 1930s, as an important American artist.

Ansel's full conversion to photography as a profession, indeed as a raison d'être, was fostered by "a little man with a mighty heart and a luminous spirit" — Albert Bender. A prosperous San Francisco insurance magnate, his real life was as a patron of arts and artists, and his influence on the Bay Area's still-nascent culture was to be significant and

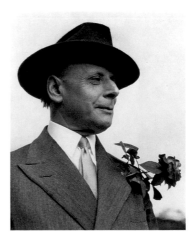

Albert Bender, c. 1928

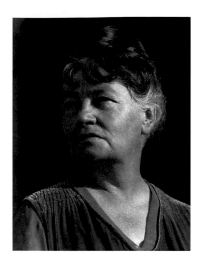

Mary Austin, c. 1929

little Old World village nestles close to the hills. Adobe — bells — color beyond imagination — and today, the heavens are filled with clouds." Shaped as he was by the untrammeled Sierran wilderness, Ansel was entranced by the mystical New Mexican trinity: the magnificent landscape of mountain and mesa, the fascinating marriage of Spanish and Indian cultures, and the exquisite architecture of ancient lineage. But, perhaps most of all, he loved the *light* — that element of ultimate importance to a photographer. As he later wrote of his first morning in Santa Fe, "All was diamond bright and clear, and I fell quickly under the spell of the astonishing New Mexican light."

Thanks to Albert Bender's magic and his own enthusiastic personality, aided and abetted by virtuoso skills at the piano — not to mention a fondness for alcohol-fueled parties — Ansel was quickly accepted in the society of Santa Fe and Taos. John Marin, the painter whom both Stieglitz and Ansel so admired, related (in a 1945 interview):

I was at Mabel's in Taos — I guess it was around 1929 — when in came a tall, thin man with a big black beard. Laughing, stamping, making a noise. All the other people crowded around him. Made even more noise. I said to myself, I don't like this man. I wish he would go away. Then all the other people hauled him to the piano — and he sat down and struck one note. One note. And even before he began to play, I knew I did not want him to go away. Anybody who could make a sound like that I wanted for my friend always.

The significance of this assimilation into the artistic community of Santa Fe and Taos for Ansel's evolution cannot be overstated. He became intimately involved with an extraordinarily creative — and empathetic — group of artists and writers. He entered into vital lifelong friendships. He exchanged ideas and inspiration with, among others, the painter Georgia O'Keeffe (who was also the wife of the great Stieglitz), the photographer Paul Strand, the poet (and partyist) Witter Bynner — as well as with Mary Austin, Mabel Dodge Luhan, and their numerous other

lasting. Ansel, perhaps his favorite protégé, was a somewhat awkward youth of twenty-four, still living at home with his elderly parents and maiden aunt when they met in 1926. Under Albert's enthusiastic and imaginative wing Ansel flourished. Most important, he helped Ansel find his métier and gain essential self-confidence.

In April 1927, Albert felt it was time for Ansel to experience the artistic New World of Santa Fe and Taos. So off they went in Albert's open touring car, mostly over dirt roads, often washboard or worse — twelve hundred long and adventurous miles. Albert introduced Ansel to his many friends in the celebrated arts colony of northern New Mexico. In Santa Fe, Ansel met the formidable Mary Austin, grande dame of the Western literati. Albert promptly proposed collaboration on a book between Ansel and Austin! He then took Ansel up to Taos and Mabel Dodge Luhan, doyenne of American salonists. Austin and Luhan were to play vital roles in the next few critical years in Ansel's life.

He was immediately enchanted. From Taos, he wrote his future wife, Virginia, "This is the most completely beautiful place I have ever seen. A marvelous snowy range of mountains rises from a spacious emerald plain and this

guests. The combined force of these remarkable people and their intellectual intensity caused Ansel — artistically, as it were — to grow up almost overnight. He metamorphosed, in five short years, from a young, would-be concert pianist and photographic amateur into one of America's most dynamic and articulate artists. San Francisco formed Ansel, the Yosemite Sierra first inspired him, but it was New Mexico that brought him to fruition. As his intimate friend and biographer Nancy Newhall so aptly put it, "Taos and Santa Fe were his Rome and Paris."

The initial project that came of Ansel's already passionate love affair with the Southwest was *Taos Pueblo* — done, as Albert had suggested, in collaboration with Mary Austin. She was an exacting colleague and mentor, but Ansel was to learn her lessons well. He worked on *Taos Pueblo* for the better part of two years, returning again and again to the pueblo to make photographs. The book was truly handmade, a triumph of the bookmaker's art. Crane and Company manufactured a special run of paper. Half was reserved for the text, which was beautifully printed with hand-set type by San Francisco's renowned Grabhorn Press. Ansel's friend Will Dassonville photosensitized the remaining paper, and Ansel went into the darkroom and personally made each print in the book (a total of 1,300 individual photographic prints!). It was then exquisitely hand-bound in linen with a spine of Nigerian goatskin — one hundred eight copies in all. *Taos Pueblo* was offered at the then exceptionally high price of $75 and, despite the depression, sold out in short order. Ironically, Ansel's first book — despite its success — was to be the last in the style of his early work. Indeed, just as he was completing *Taos Pueblo*, he encountered an artist who was to fundamentally alter his vision of photography.

Ansel was essentially self-educated. In his formative years there were few art schools and none for creative photography. In any event, he had floundered in traditional schools. (Probably dyslexic and hyperactive, he was largely taught at home.) As a result of this unusual

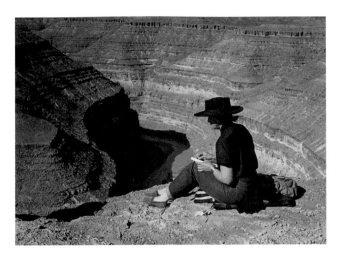

Georgia O'Keeffe sketching, 1937

academic career, Ansel did not emerge as part of an obvious artistic tradition. Nonetheless, his photography had broadly reflected the contemporary Pictorialist style. Then, in August 1930, at Mabel Dodge Luhan's, Ansel met Paul Strand, one of the prominent members of the Stieglitz "circle." Together, they viewed a large number of negatives Strand had made during his stay in New Mexico. Ansel later wrote, "For the first time I saw images revealing a powerful perception and conviction. I was turned from a quasi-pictorial approach to a far more precise and austere vision." He added (in 1972) that "a great and enduring light was turned on for me which persists until this day. For the first time I could recognize what straight photography was. It was not a matter of imitation, but of revelation. Awareness came upon me like a spring flood. I began to understand and deeply admire the work of Edward Weston." And, later still, "[Strand's] photographs were extraordinary. The wonderful, efficient space and the purity of his edges. It's very trite to try and talk about it, but these really excited me. I arrived back in San Francisco all fired up. I immediately went into the straight phase of photography, using an 8-by-10 camera and getting sharp negatives, getting the pure photographic image."

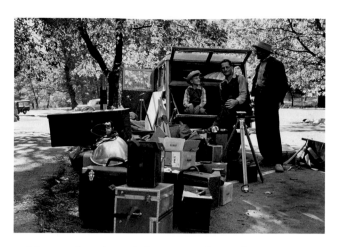

Adams packing the car before a trip to the Southwest, with his son, Michael, and Cedric Wright, 1941 (by Virginia Adams)

As time went by, Ansel often expanded his explanation of the impact of seeing Strand's work to credit the experience for his decision against music and in favor of photography. His contemporary correspondence does not bear this out. Neither does a third-person statement either written or carefully edited by him (c.1932):

Was trained as a musician. The camera, however, had always interested him, and in 1927 he finally relinquished the piano and gave full attention to photography. It is interesting to note that his first work was definitely pictorial; while he seldom manipulated his negatives and prints, his compositions were more in the style of conservative painting, his conceptions slightly tinged by romanticism, and his prints revealed his pleasure in textured papers and impressively expensive presentations. It was not until 1931 that the veil of relative inessentials was torn away, and the emergence of a pure photographic expression and technique was revealed.

Although Stieglitz and Weston were to be Ansel's *great* friends and, in many ways, his mentors, the artist who most influenced his work was Paul Strand.

Despite his growing fame as an artist, Ansel had to make his living as a teacher, writer, and, especially, as a commercial photographer and photojournalist. In this role he made many visits to the Southwest, particularly in the 1940s and 1950s, working for a diversity of clients. His assignments came from, among others, Eastman Kodak, U.S. Potash Company, *Arizona Highways, Time,* and *Life,* as well as from the Interior Department. In pursuit of these projects — and on Guggenheim Fellowships — he traveled repeatedly across the Southwest, from Big Bend National Park in Texas to Death Valley in California, from southern Utah and Colorado to the Mexican border. It would be difficult to imagine that many Americans, between 1927 and 1961, drove more miles on the bad and back roads of the Southwest than Ansel Adams — and doubtful that any American expressed a visual resonance with the region as deeply convincing.

From the very beginning of his involvement in the Southwest, Ansel understood that the wondrous mix of cultures, Spanish and Indian, with the largely unspoiled landscape was evanescent. In his autobiography he wrote,

While the Southwest natural scene has always seemed beautiful and inviting, the human experience has often been otherwise as I glimpsed vistas of the surge of its history. What I experienced in the 1927–1946 years was a time of pause between two periods of exploitation — the Spanish Conquest of the past and the Anglo conquest of the future — when the human pageant was in quiet suspense and the natural character and integrity of the land was temporarily secure.

Unlike the Yosemite Sierra, which, quite literally, had been made world-famous by nineteenth-century photographers — particularly Carleton Watkins and Eadweard Muybridge — the Southwest was largely unknown in visual terms. In 1928, Ansel wrote in a letter, "Albert, I have a strong feeling that this land is offering me a tremendous opportunity; no one has really photographed it."

Well . . . Ansel did.

WILLIAM A. TURNAGE

THE GRAND CANYON AND THE SOUTHWEST

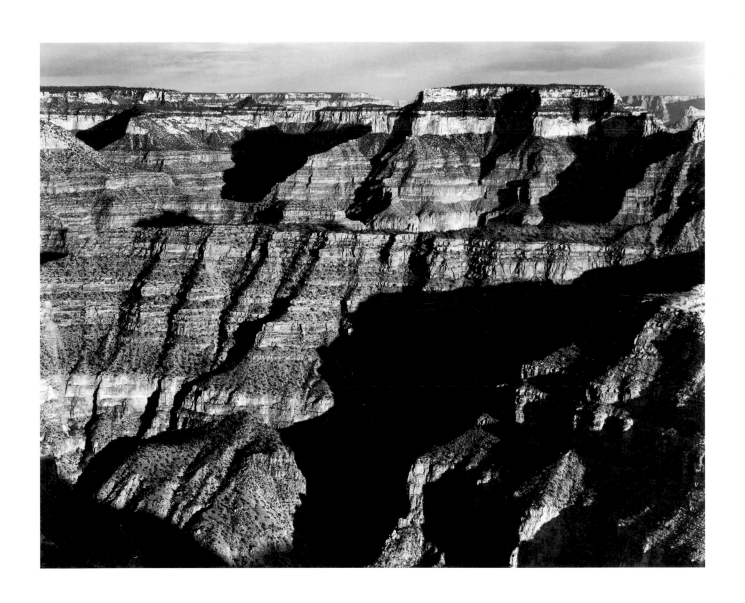

Grand Canyon National Park, Arizona, 1942

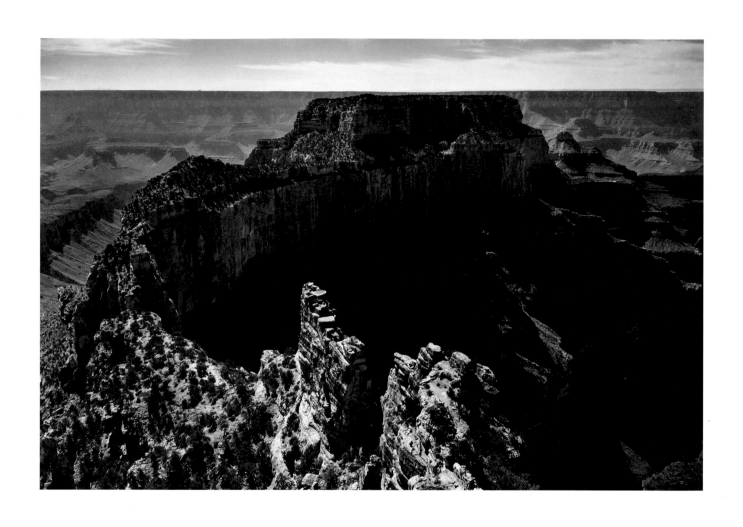

Grand Canyon from Cape Royal, Grand Canyon National Park, Arizona, c. 1942

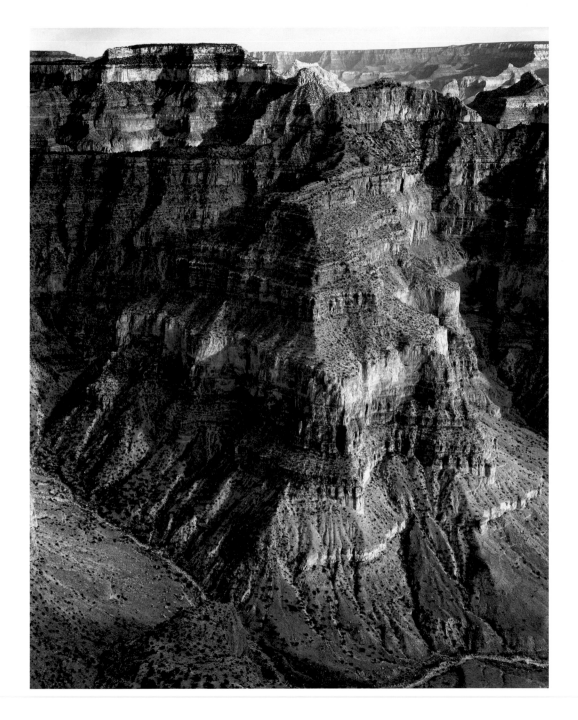

Grand Canyon from Point Sublime, Grand Canyon National Park, Arizona, 1942

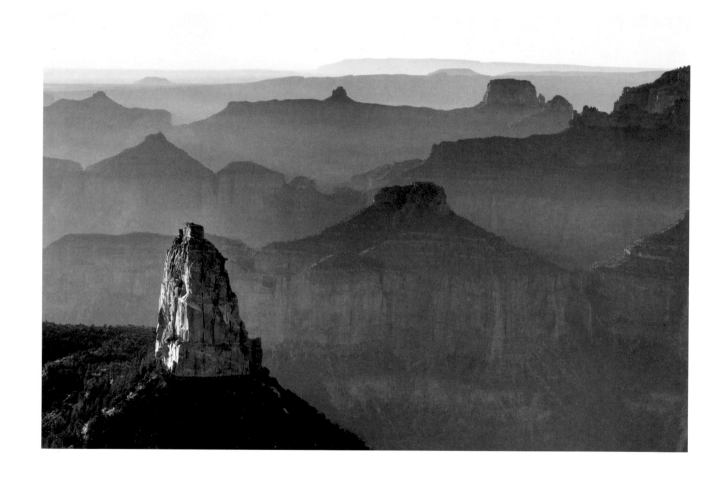

Grand Canyon from Point Imperial, Grand Canyon National Park, Arizona, c. 1942

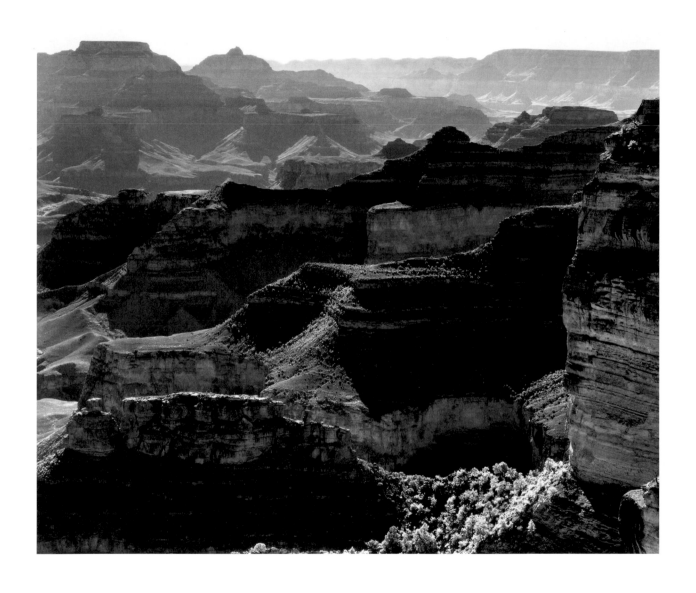

Grand Canyon of the Colorado River, Grand Canyon National Park, Arizona, c. 1942

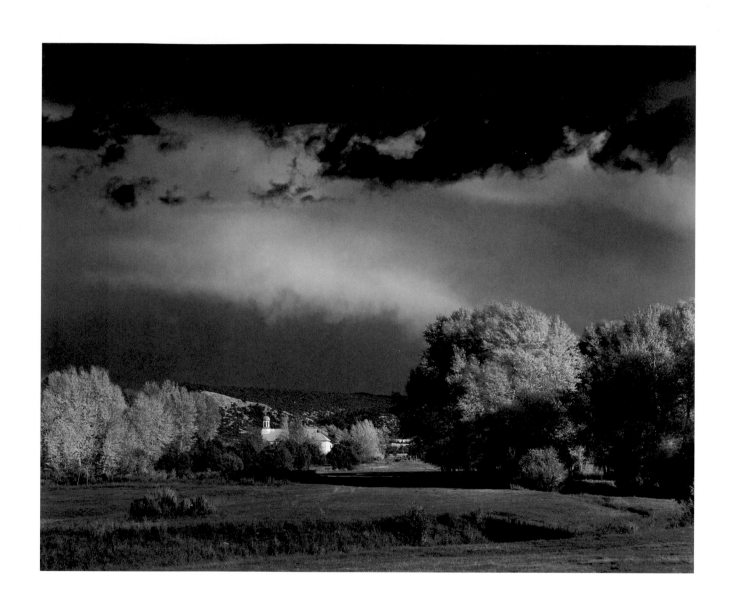

Autumn Storm, Las Trampas, near Penasco, New Mexico, c. 1958

It is all so very beautiful and picturesque, and the air and mountains and people are so fine that I am completely "gone" on the land.

From a letter to Virginia Adams, November 1928
Santa Fe, New Mexico

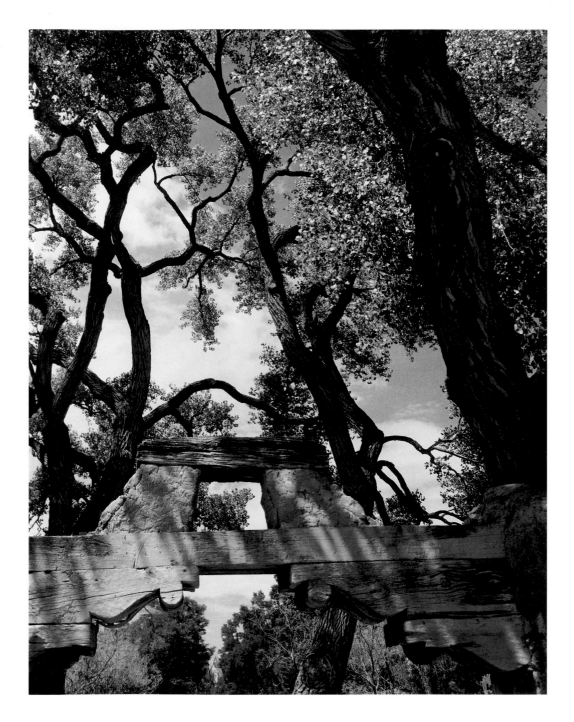

Gate, Nambe Road, near Pojoaque, New Mexico, 1973

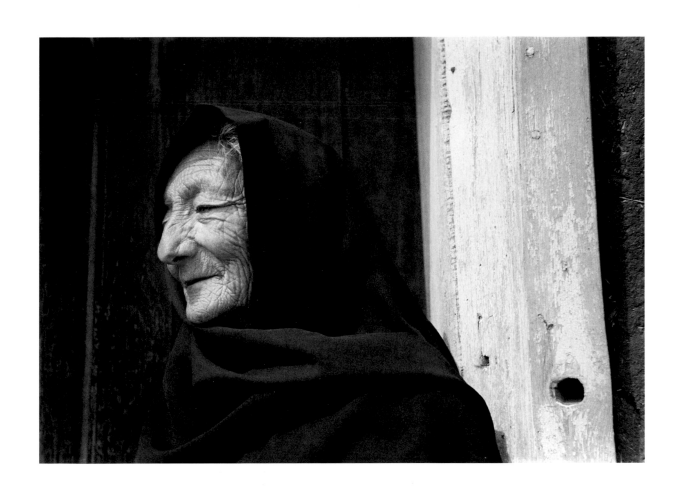

Spanish-American Woman, near Chimayo, New Mexico, 1937

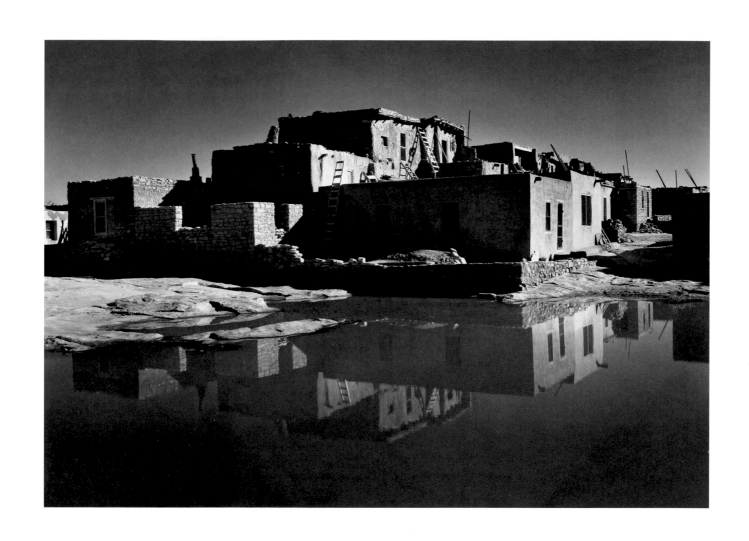

Pool and Buildings, Acoma Pueblo, New Mexico, 1942

The most remarkable spot I ever expect to see was the Pueblo Acoma — an Indian village of great antiquity set on a lofty mesa in a wild desert landscape . . . impossible to tell of the beauty of the place and the effect of color — the cream rocks and earth — the green blue desert and the brilliant reds and yellows and blacks of the Indian costumes. We must *see it. . . .*

From a letter to Virginia Best, May 1927
Acoma Pueblo, New Mexico

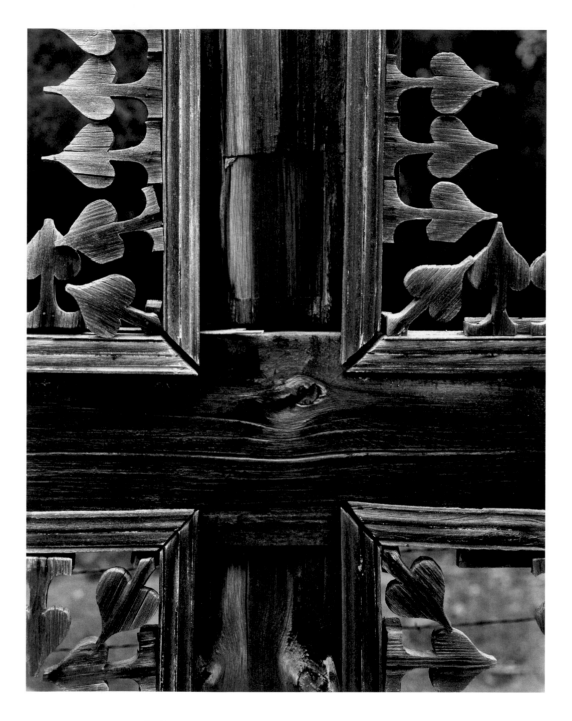

Detail of Old Cross, Las Trampas Church, New Mexico, c. 1951

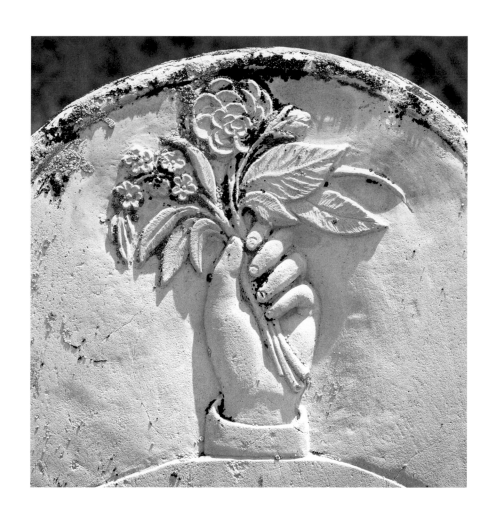

Gravestone, Orderville, Utah, c. 1961

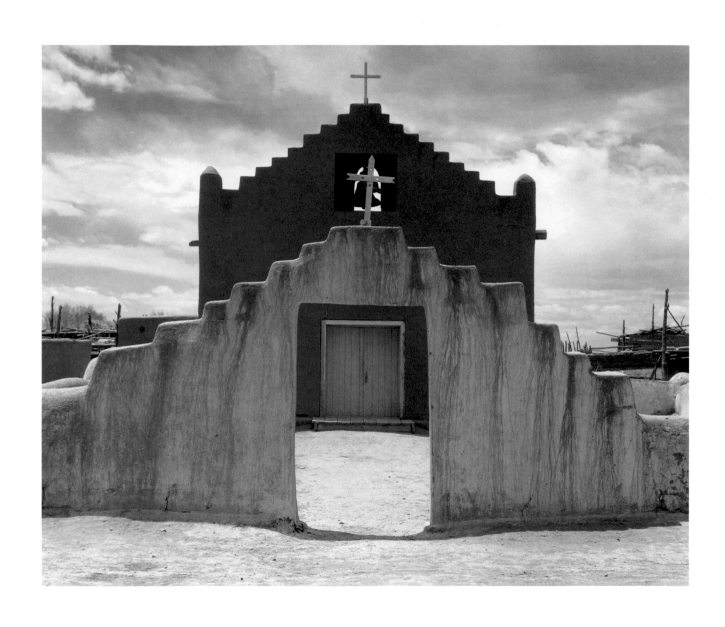

The New Church, Taos Pueblo, New Mexico, c. 1928

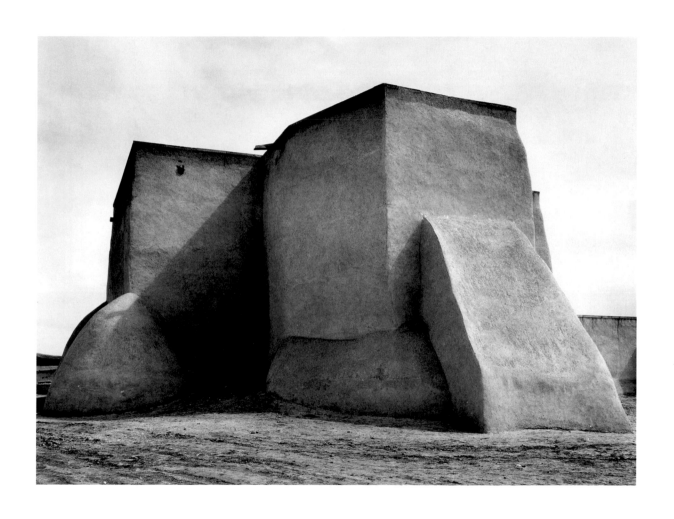

Saint Francis Church, Ranchos de Taos, New Mexico, c. 1929

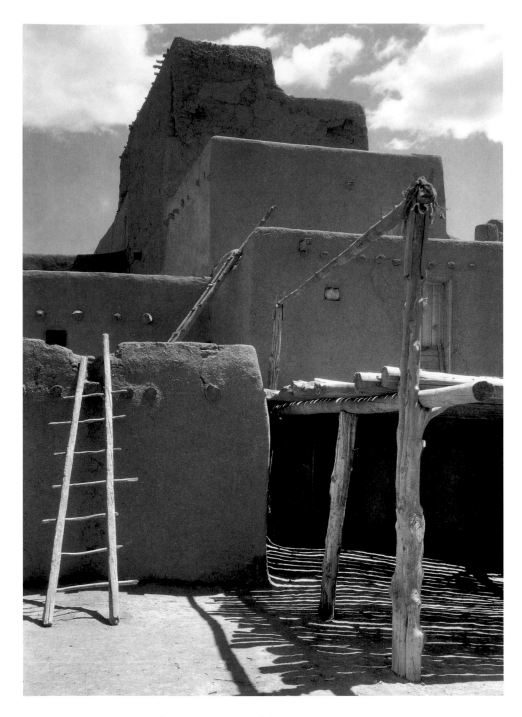

North House, Taos Pueblo, New Mexico, c. 1929

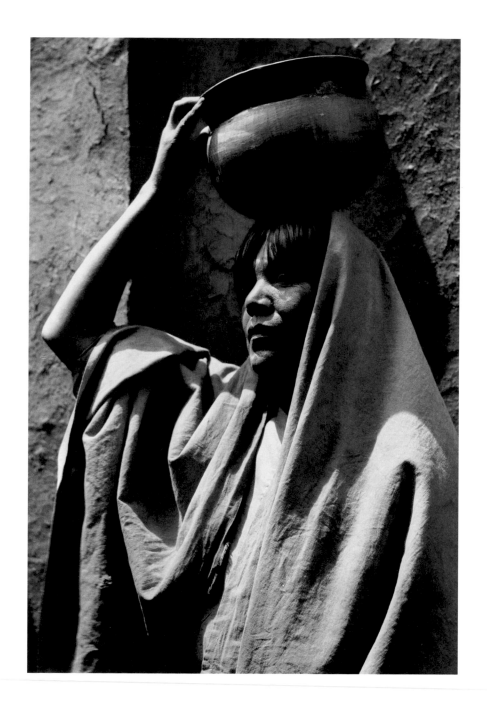

Girl of Taos, Taos Pueblo, New Mexico, c. 1929

The clouds are coming up and I feel the itch to click the shutters.

From a letter to Virginia Adams, September 1937
Ghost Ranch, Abiquiu, New Mexico

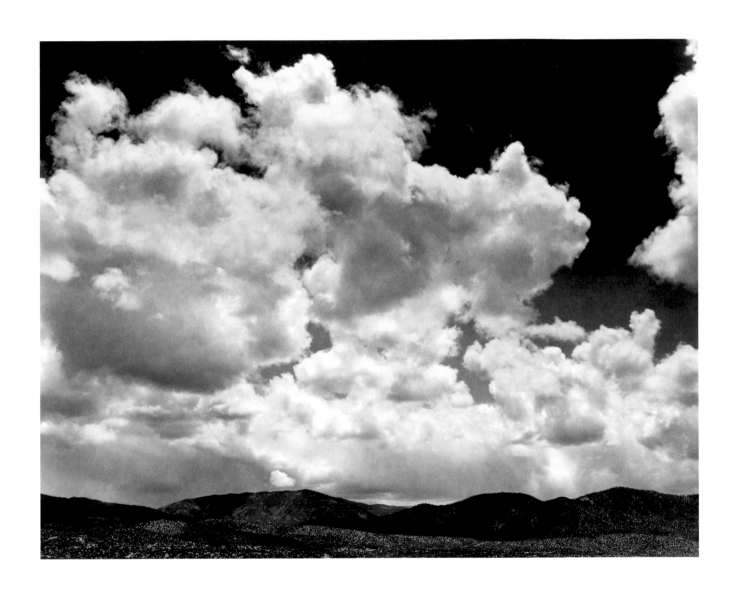

Clouds, New Mexico, 1933

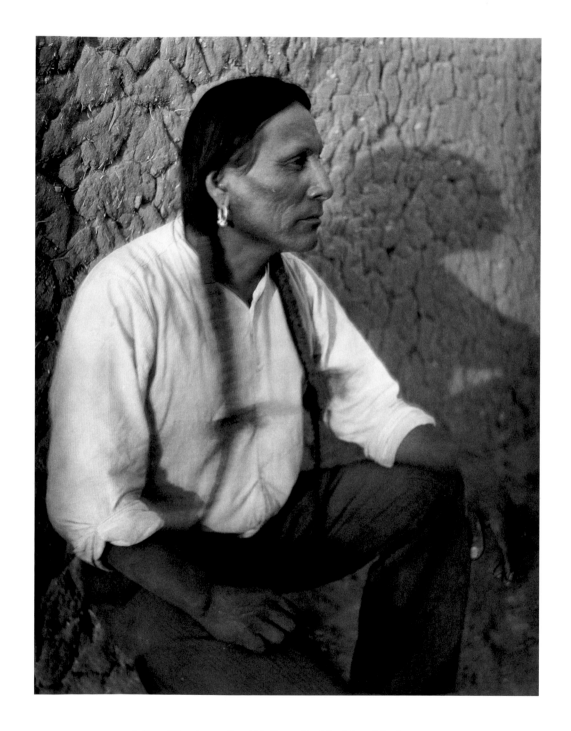

Julian Martinez, San Ildefonso Pueblo, New Mexico, 1928

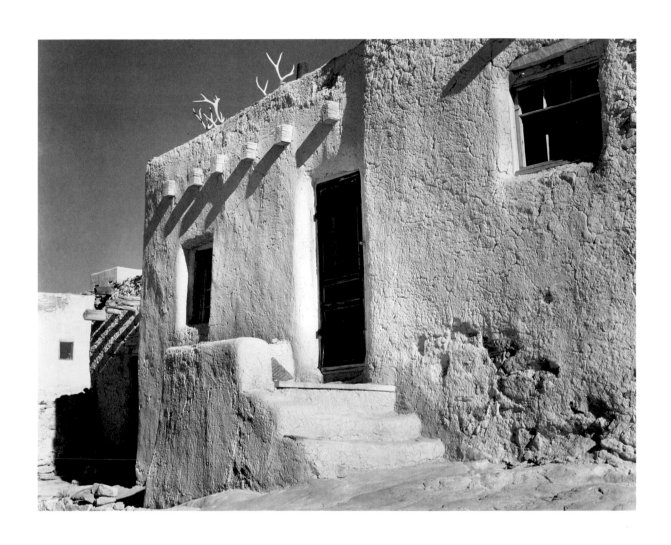

House, Laguna Pueblo, New Mexico, c. 1930

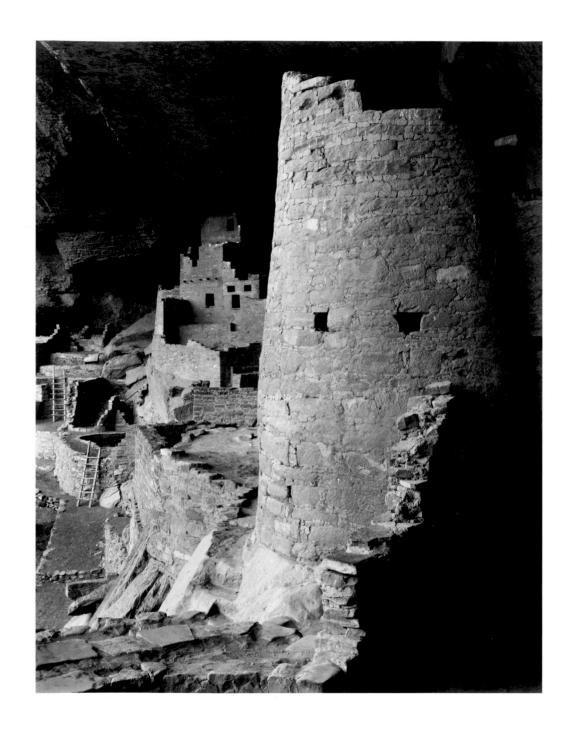

Cliff Palace Detail, Mesa Verde National Park, Colorado, 1942

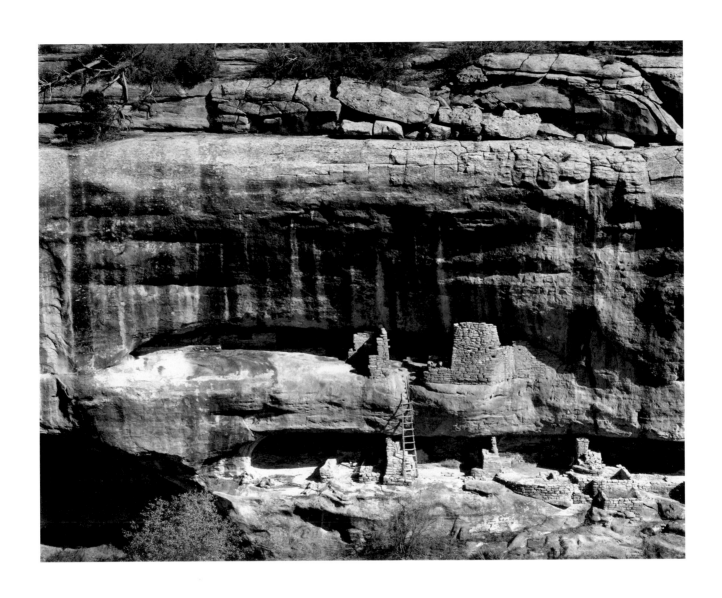

Cliff Palace Ruin, Mesa Verde National Park, Colorado, 1942

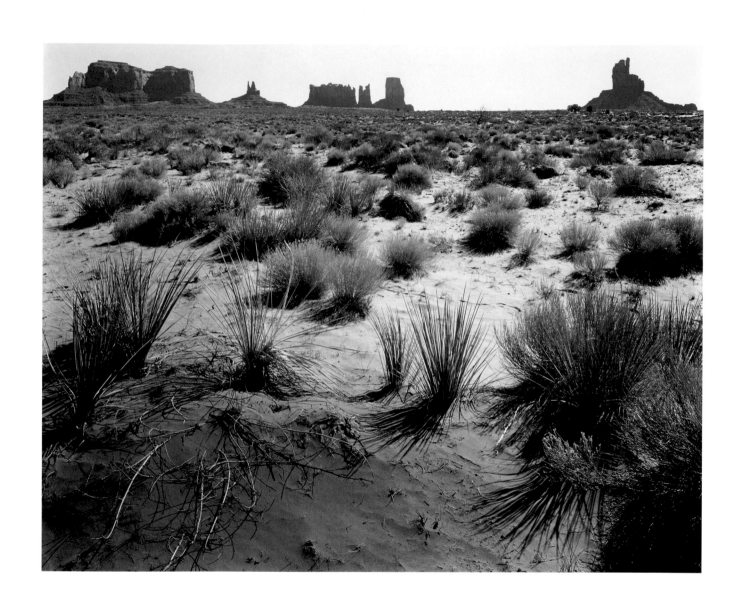

Monument Valley, Arizona, c. 1947

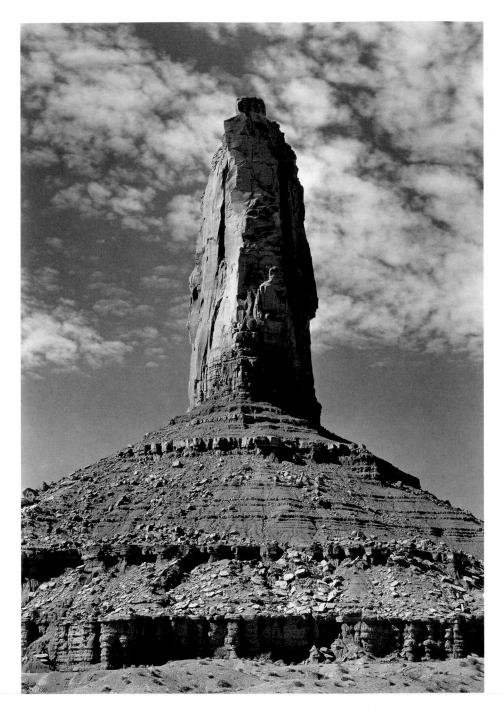

Monument Valley, Arizona, 1937

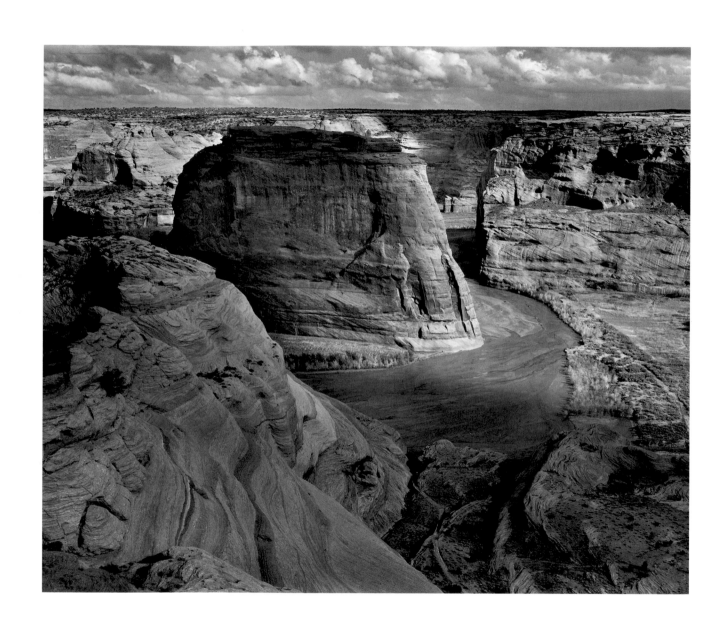

Canyon de Chelly National Monument, Arizona, 1942

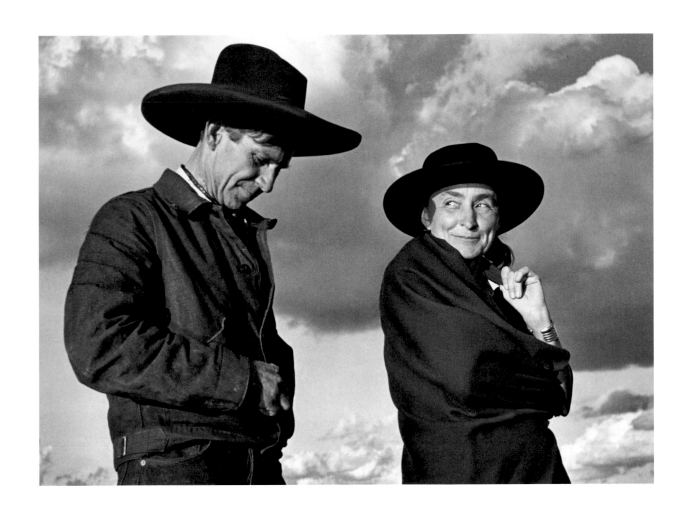

Georgia O'Keeffe and Orville Cox, Canyon de Chelly National Monument, Arizona, 1937

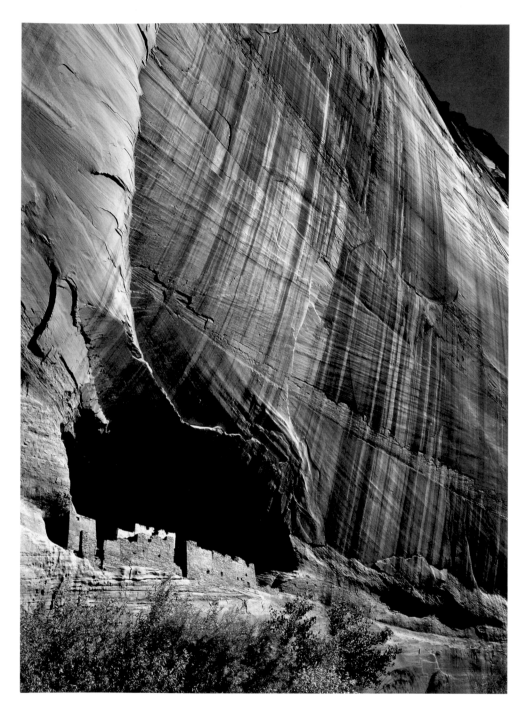

White House Ruin, Canyon de Chelly National Monument, Arizona, 1941

We have had a spectacular and dangerous trip. All went well through Death Valley, Boulder Dam, Zion, North Rim, South Rim, Cameron. Then we spent the night on Walpi Mesa, proceeded to Chinle, and had two spectacular stormy days at Canyon de Chelly. I photographed the White House Ruins from almost the identical spot and time of the O'Sullivan picture!! Can't wait until I see what I got. Then our troubles began. They have had the worst rainy season in twenty-five years and the roads through the Indian country are unbelievable. The road from Chinle to Kayenta was so terrible that it took us fifteen hours to go sixty miles; then we ended up at midnight flat on our chassis in the worst mud hole you ever saw—with lightning and thunder and rain roaring on us. We slept in the car that night and worked from 5 A.M. till noon getting the old bus rolling again.

From a letter to Beaumont and Nancy Newhall, October 26, 1941
Mesa Verde National Park, Colorado

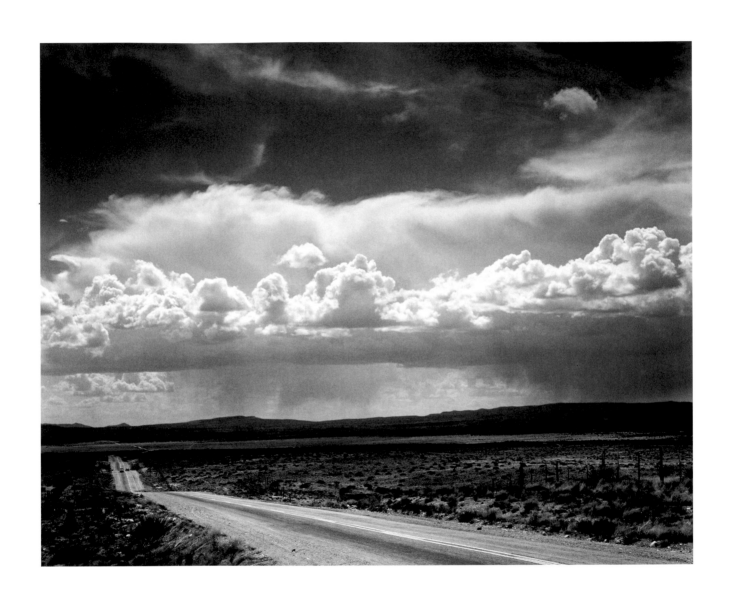

Road and Clouds, near Prescott, Arizona, c. 1930

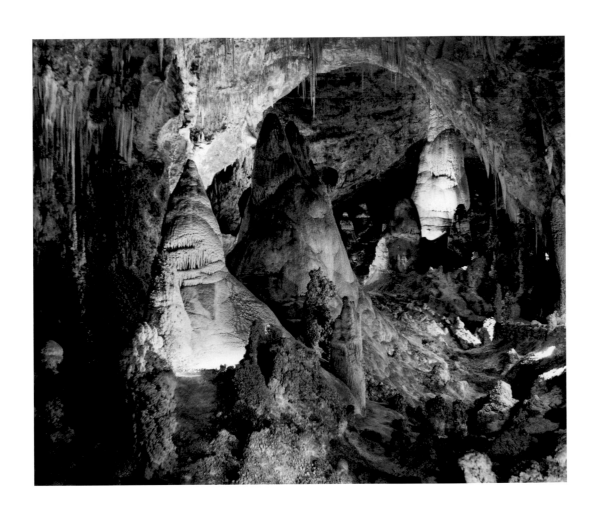

Big Room, Carlsbad Caverns National Park, New Mexico, 1942

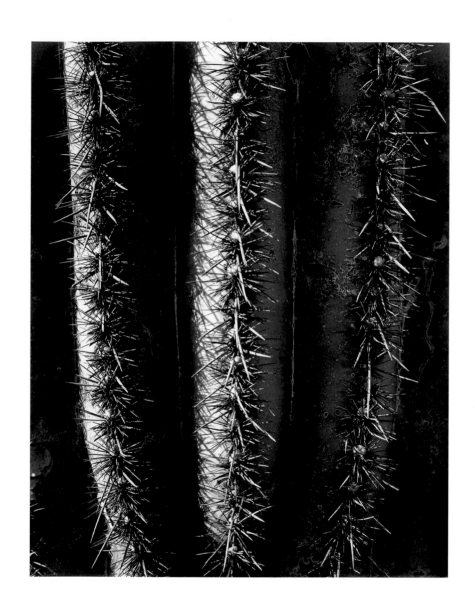

Detail, Saguaro Cactus, near Phoenix, Arizona, c. 1950

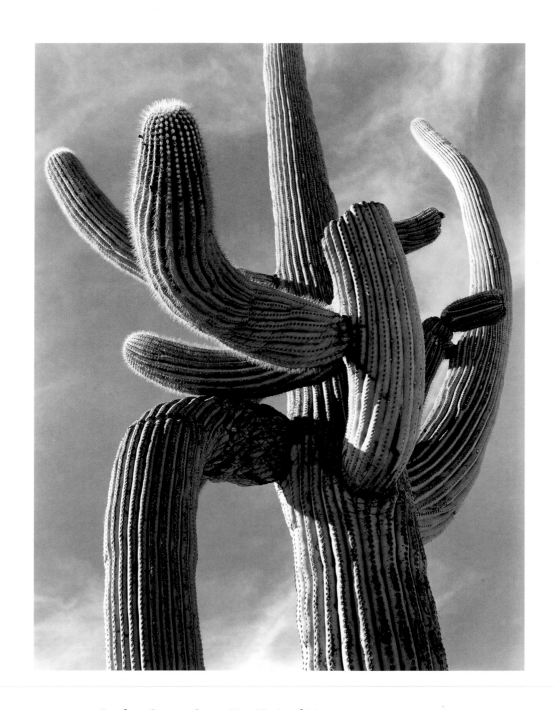

Involute Cactus, Organ Pipe National Monument, Arizona, c. 1948

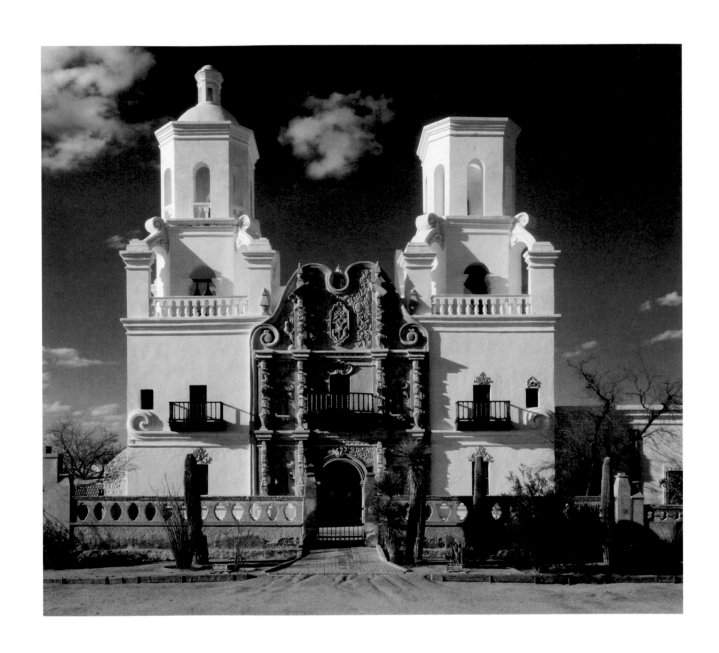

Mission San Xavier del Bac, Tucson, Arizona, 1965

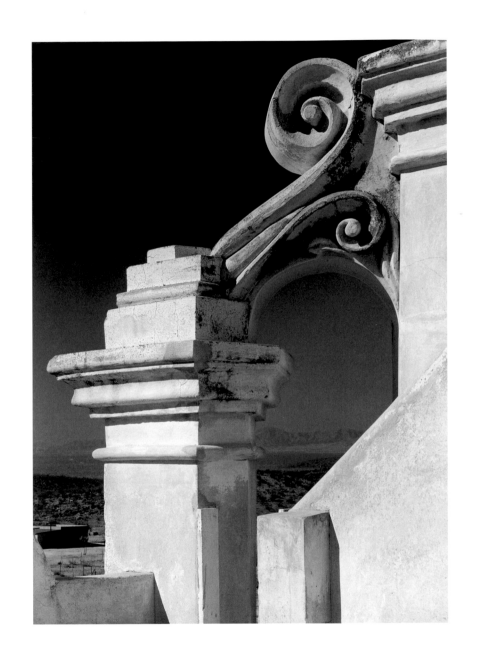

Buttress of West Tower, Mission San Xavier del Bac, Tucson, Arizona, c. 1958

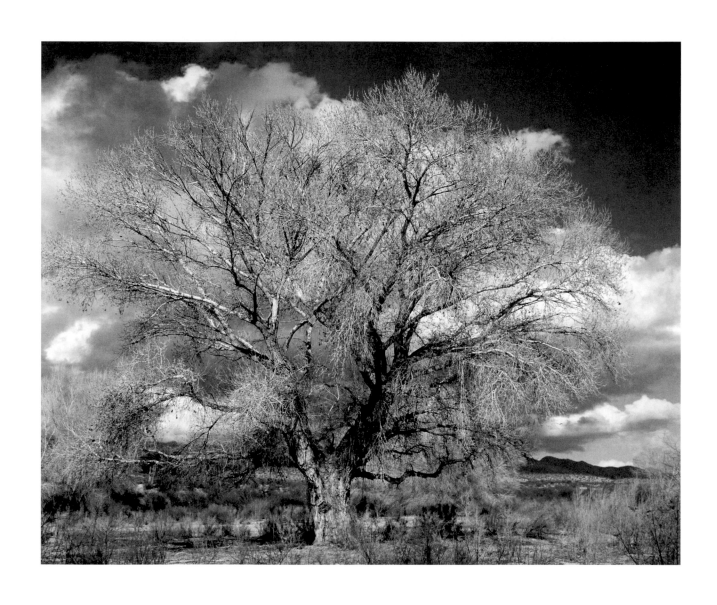

Tree and Clouds, Tucson, Arizona, c. 1944

46

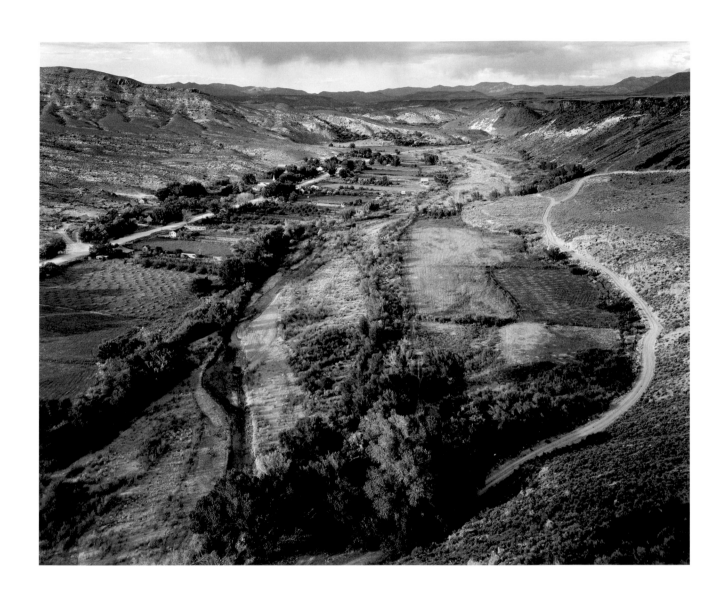

Near Gunlock, Utah, 1953

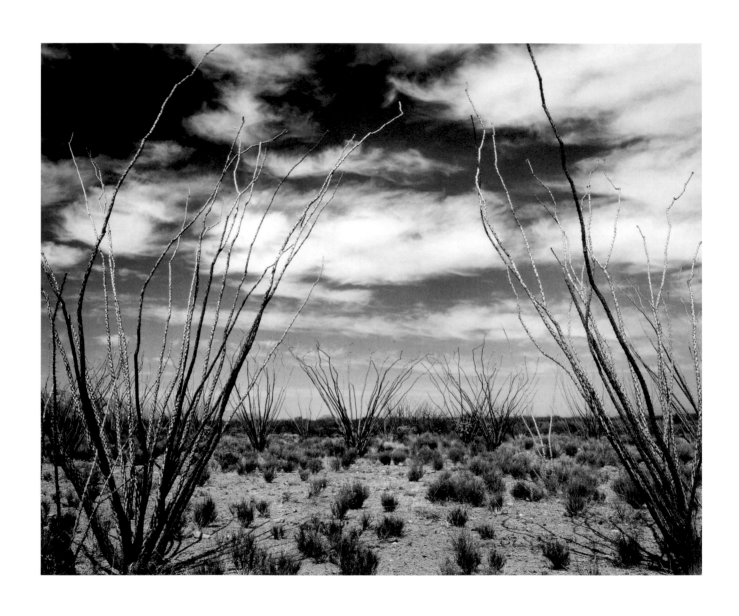

Ocotillo Cactus, near Elkhorn Ranch, Arizona, 1965

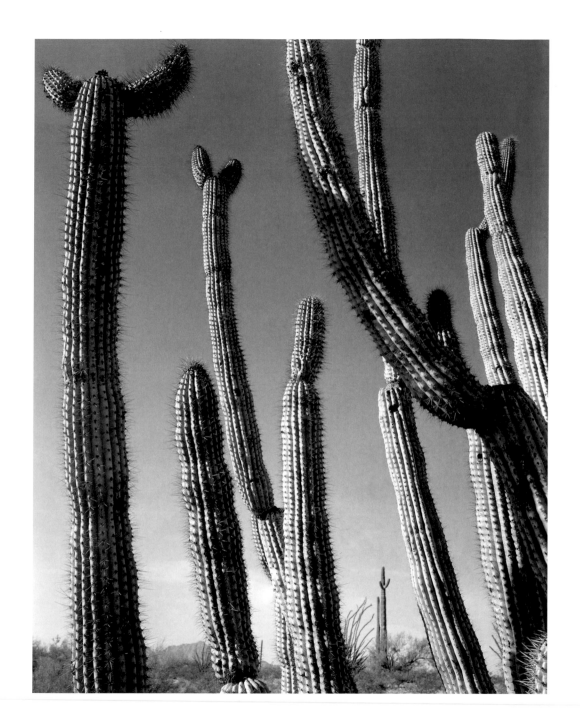

Organ Pipe Cactus National Monument, Arizona, c. 1952

Whatever you hear about Big Bend not being of National Park stature, please discount it. It is one of the grandest places I have seen, and has a magical mood that, in my mind, puts it among the top really great areas.

From a letter to Francis Farquhar, February 16, 1947
Big Bend National Park, Texas

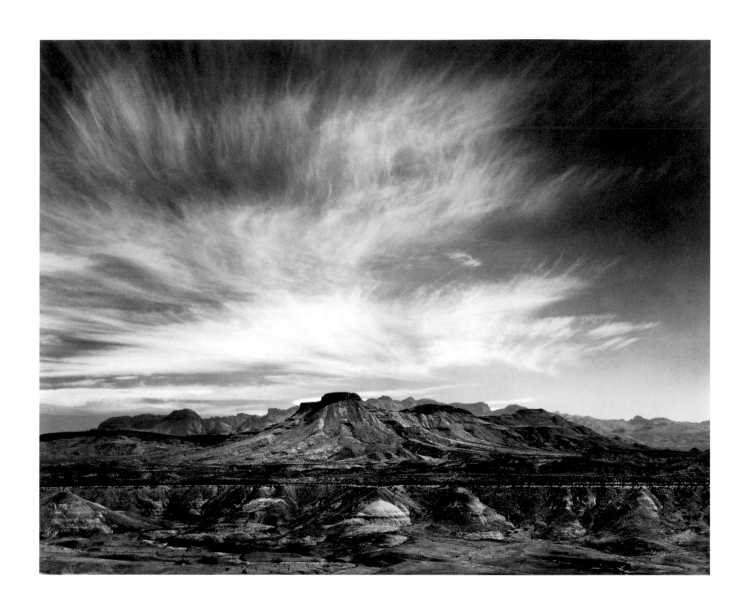

Burro Mesa and the Chisos Mountains, Big Bend National Park, Texas, 1942

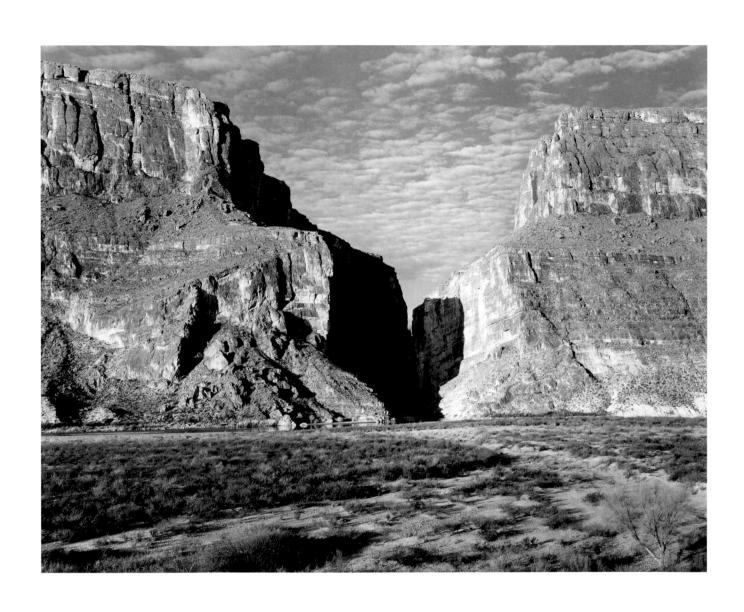

Santa Elena Canyon, Big Bend National Park, Texas, 1947

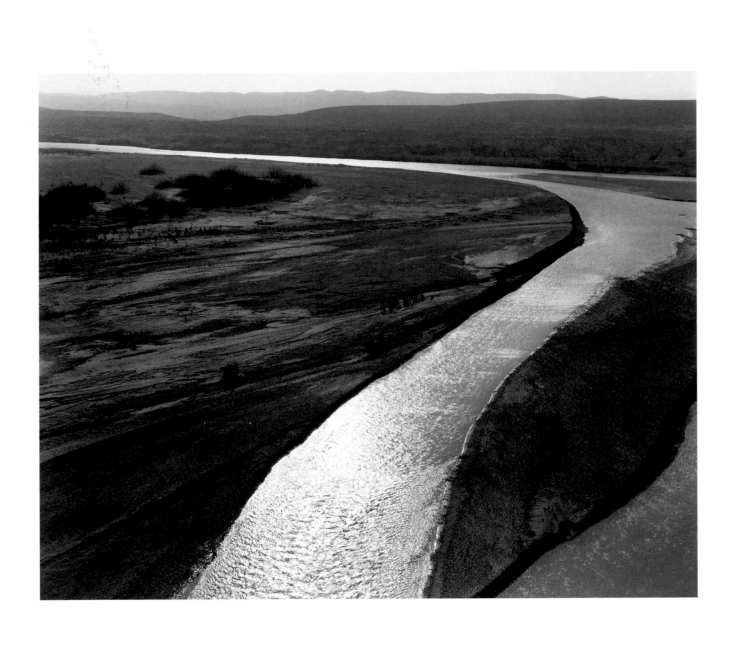

Sand Bar, Rio Grande, Big Bend National Park, Texas, 1947

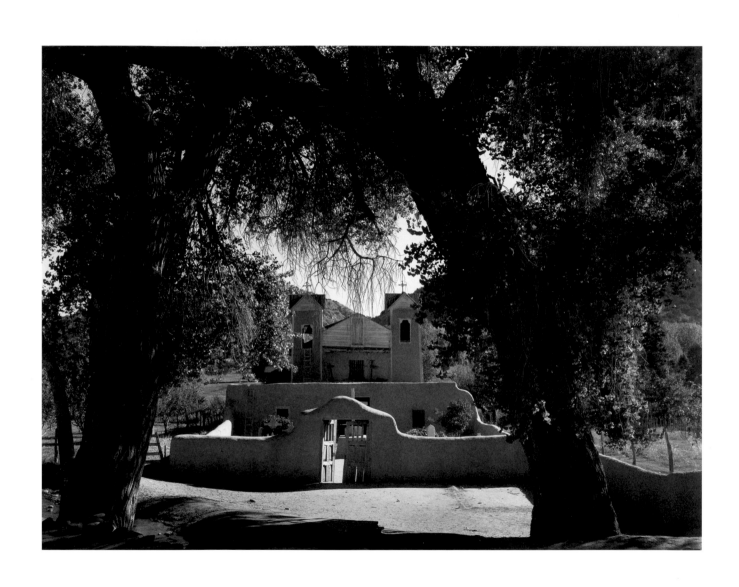

Santuario de Chimayo, New Mexico, c. 1950

Wood Carving by George Lopez, Cordova, New Mexico, c. 1960

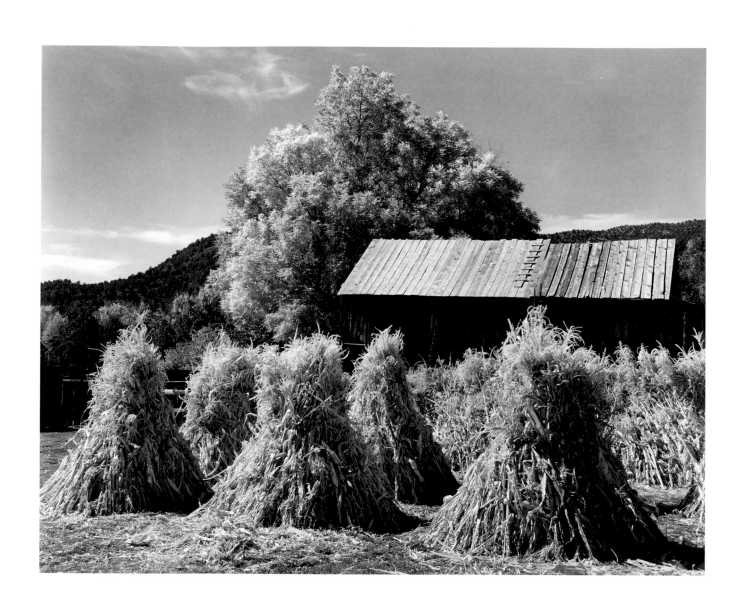

Farm, Autumn, near Glendale, Utah, c. 1940

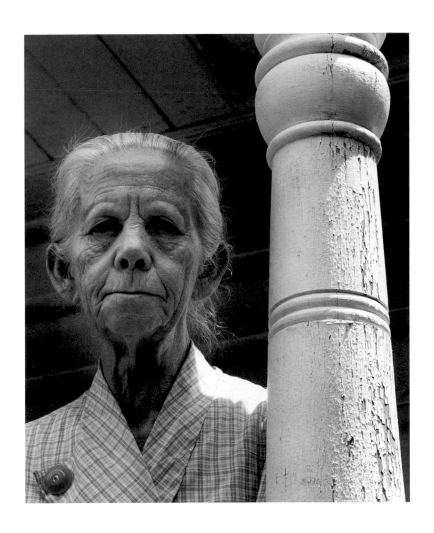

Martha Porter, Pioneer Woman, Orderville, Utah, c. 1961

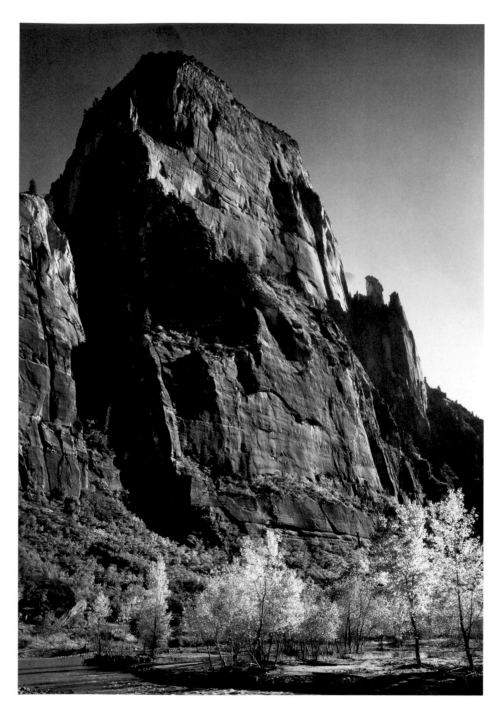

The Great White Throne, Zion National Park, Utah, c. 1942

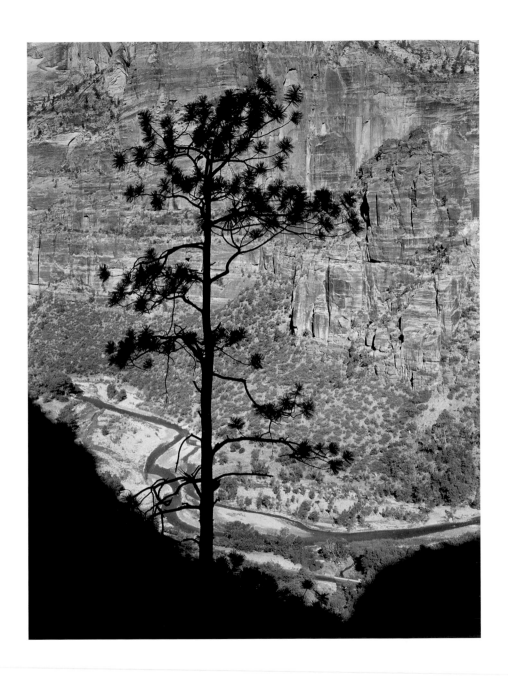

Tree against Cliff, Zion National Park, Utah, 1947

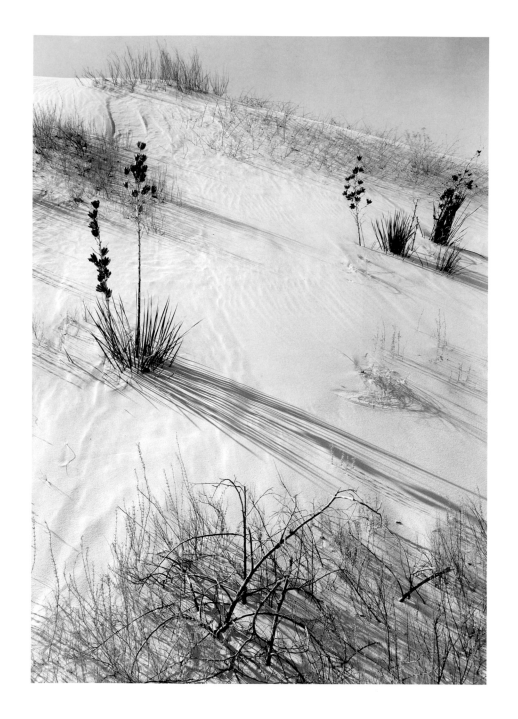

Dune, White Sands National Monument, New Mexico, 1941

This is the longest week I have ever had in my life!! Southern New Mexico—Desert—Desert, DESERT. And a cold wind is blowing and the sky is gray with furious clouds. I feel like an atom somewhere off in space between the moon and Spica!!

From a letter to Patsy English, December 1, 1936
Carlsbad, New Mexico

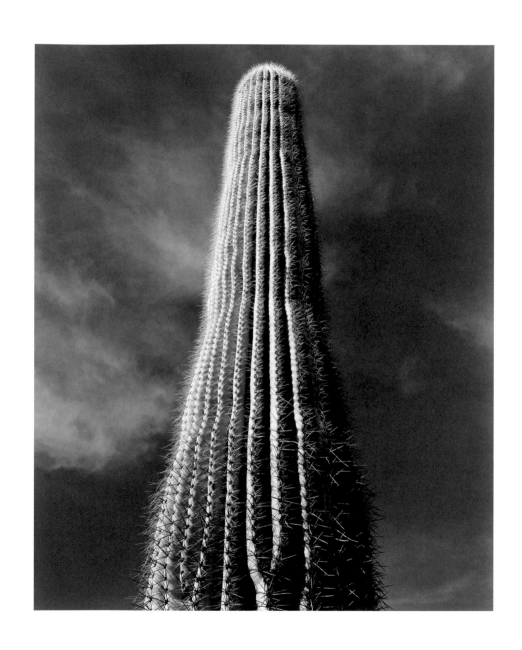

Saguaro Cactus, Arizona, 1942

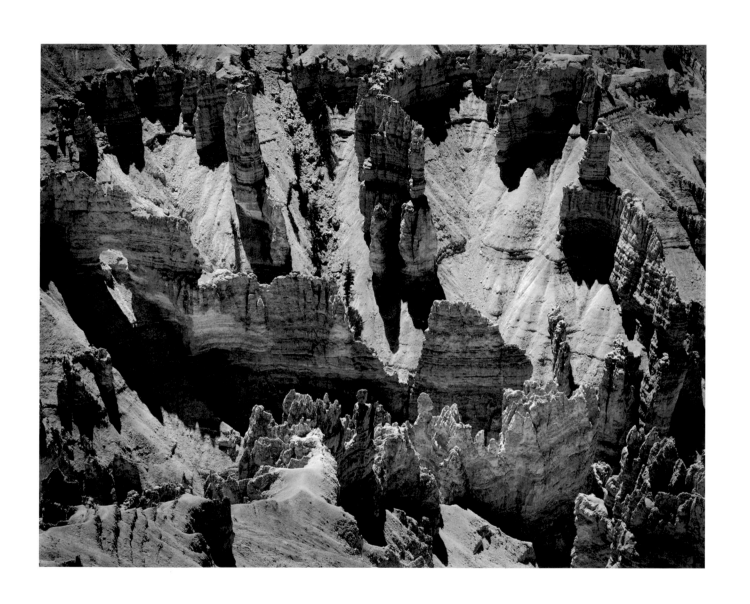

In Cedar Breaks National Monument, Utah, 1947

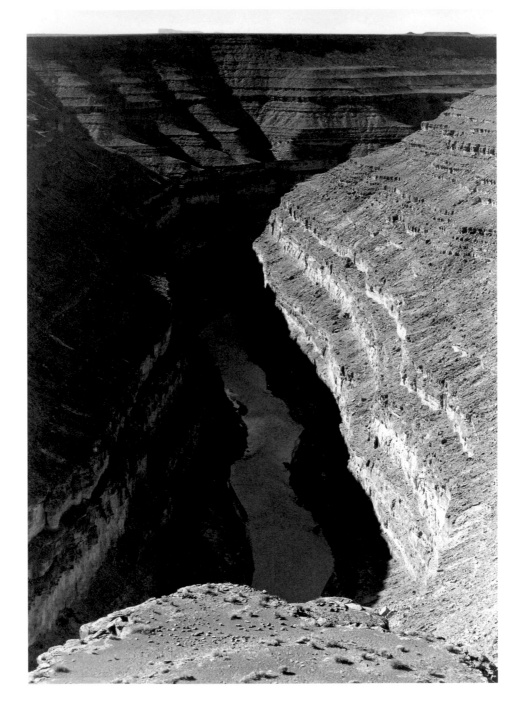

Goosenecks of the San Juan River, near Mexican Hat, Utah, c. 1940

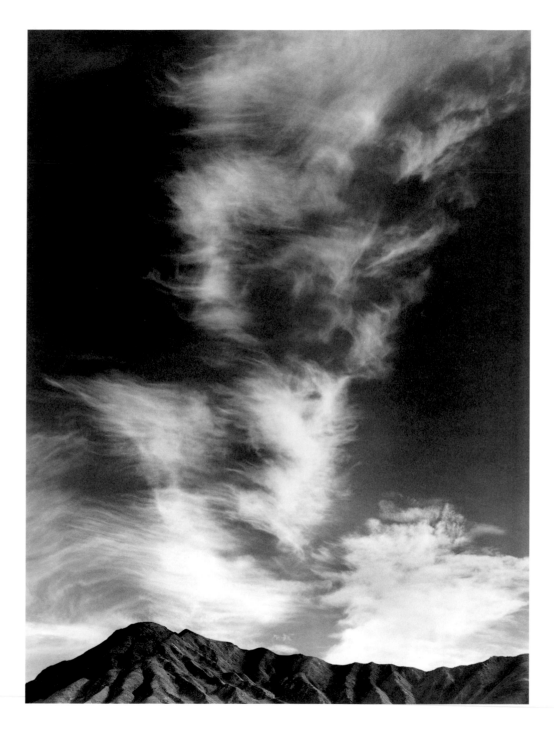

Clouds above Golden Canyon, Death Valley National Park, California, 1946

Teach, it's marvelous! Death Valley is SOMETHING! No use talking about it— it's just a tremendous nest of photographic opportunity.

From a letter to Minor White, 1947
Twenty-nine Palms, California

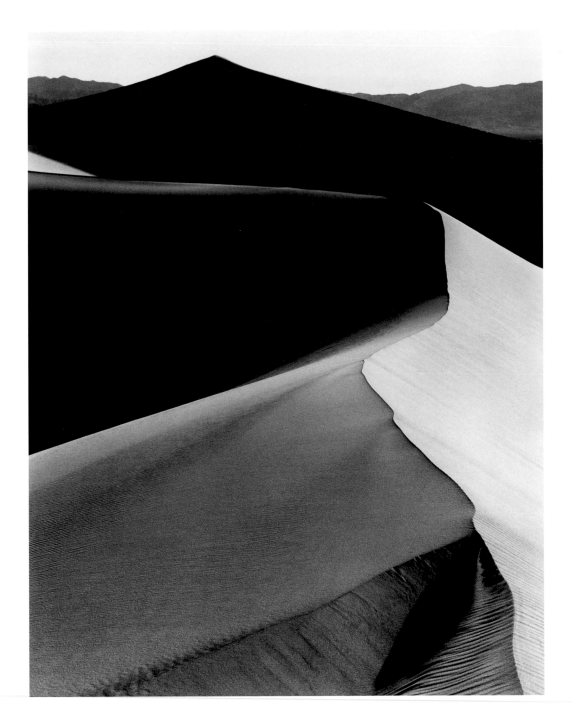

Sand Dunes, Sunrise, Death Valley National Park, California, c. 1948

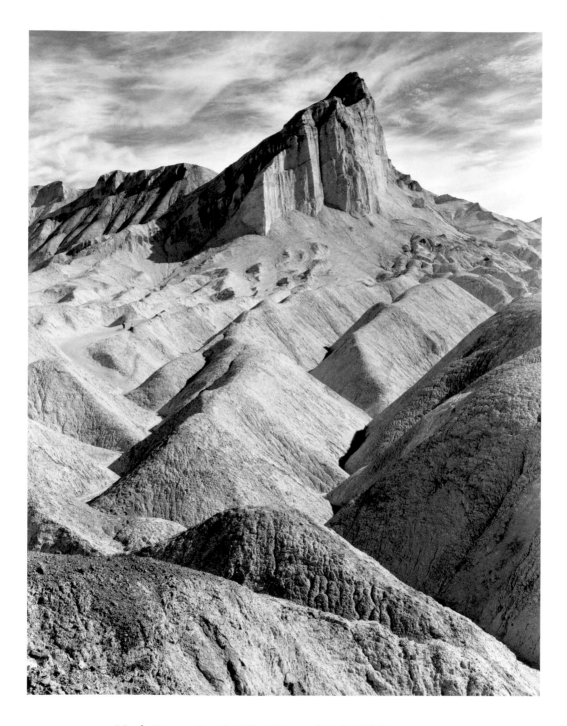

Manly Beacon, Death Valley National Park, California, c. 1952

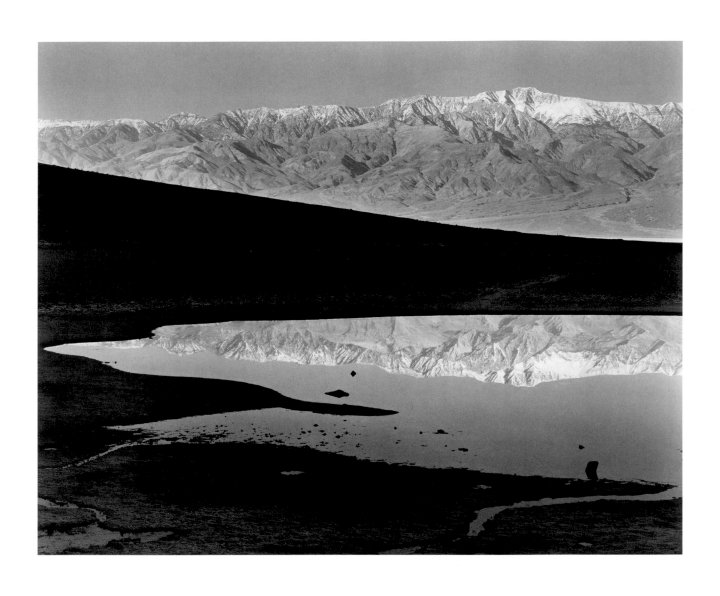

Sunrise, Bad Water, Death Valley National Park, California, 1948

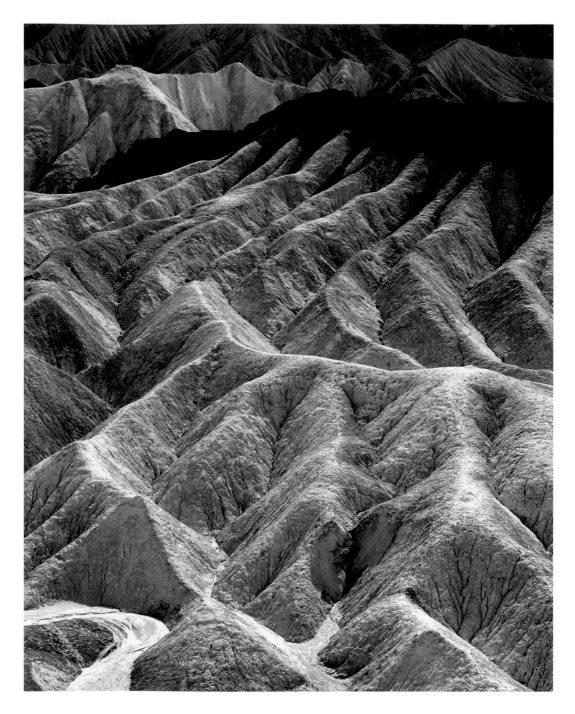

Zabriskie Point, Death Valley National Park, California, c. 1942

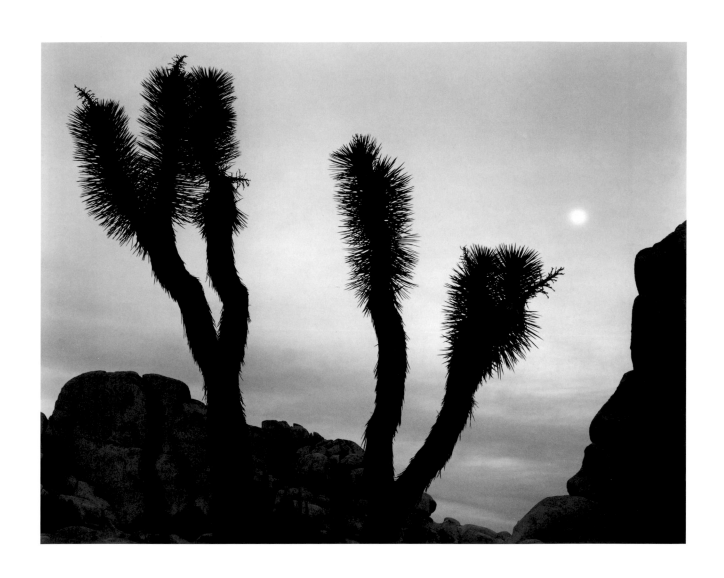

Moonrise, Joshua Tree National Park, California, 1948

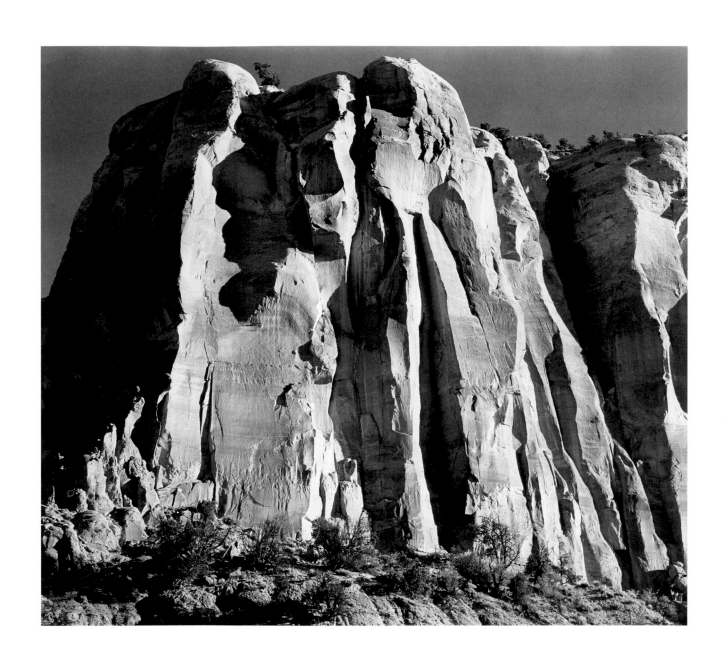

The Enchanted Mesa, near Acoma Pueblo, New Mexico, c. 1937

There is a strange quality here; I feel as if I had lived a whole life in this country, so perfectly does it seem to fit me. And I have unlimited energy and great clarity of mind. I want to work hard here—everything is so radiant.

From a letter to Virginia Adams, November 1928
Santa Fe, New Mexico

There is no use in my trying to describe this place; it beats anything I have seen anywhere for complete beauty.

From a letter to Virginia Adams, 1937
Abiquiu, New Mexico

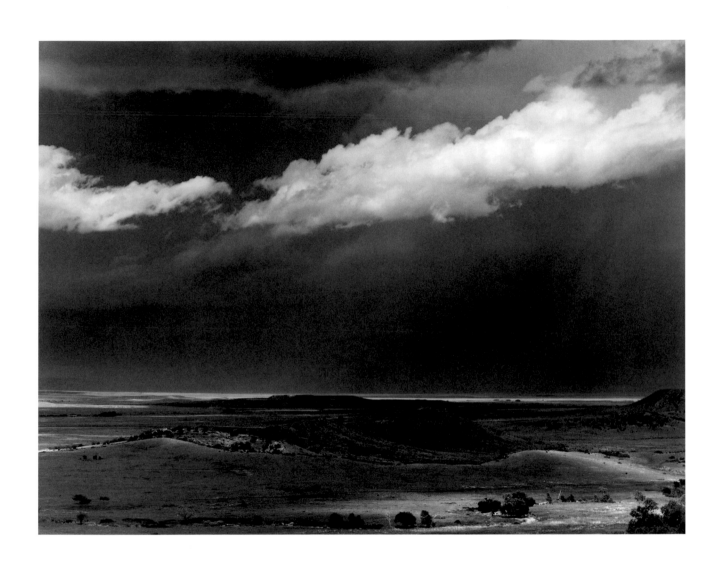

Thunderstorm over the Great Plains, near Cimarron, New Mexico, 1961

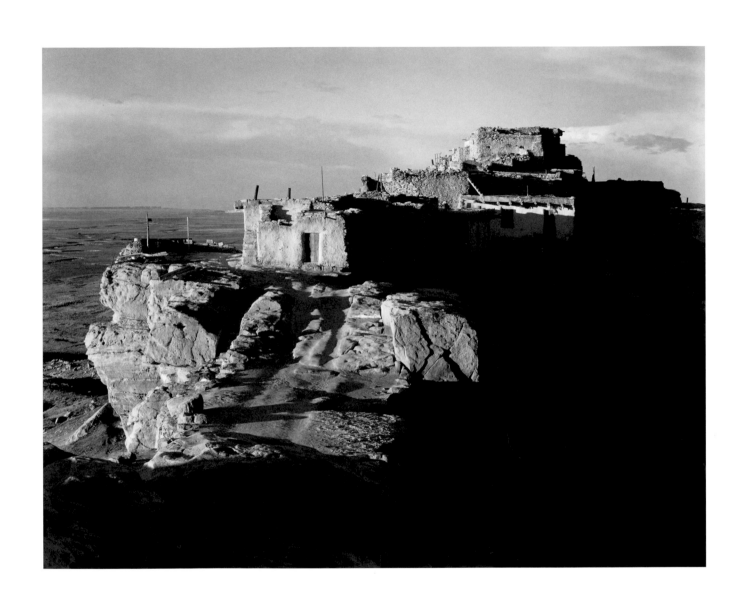

Sunrise, Old Walpi Pueblo, Arizona, c. 1942

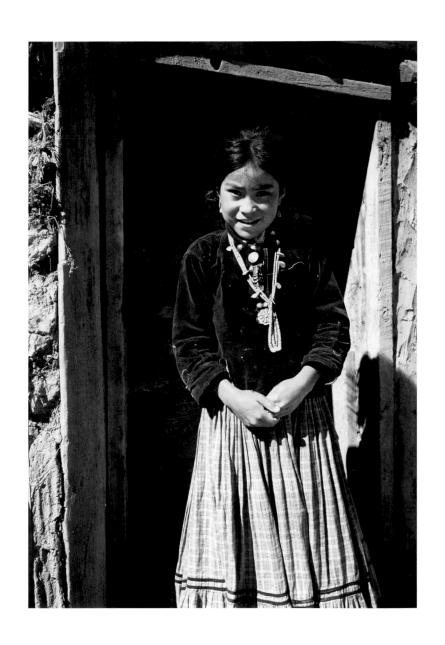

Navajo Girl, Canyon de Chelly National Monument, Arizona, c. 1941

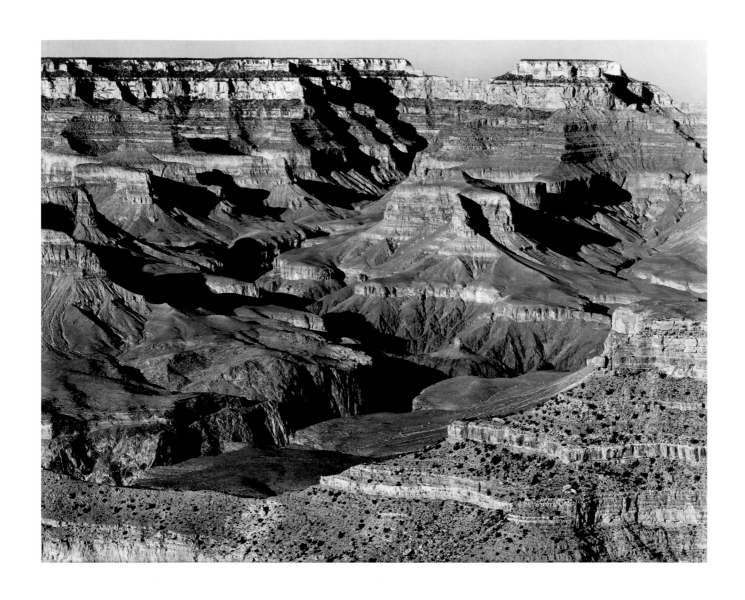

Grand Canyon from Yavapai Point, Grand Canyon National Park, Arizona, 1942

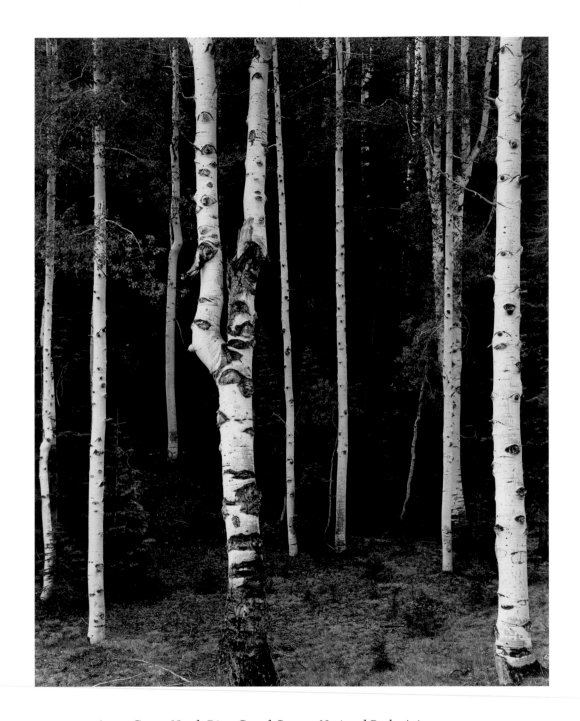

Aspen Grove, North Rim, Grand Canyon National Park, Arizona, c. 1942

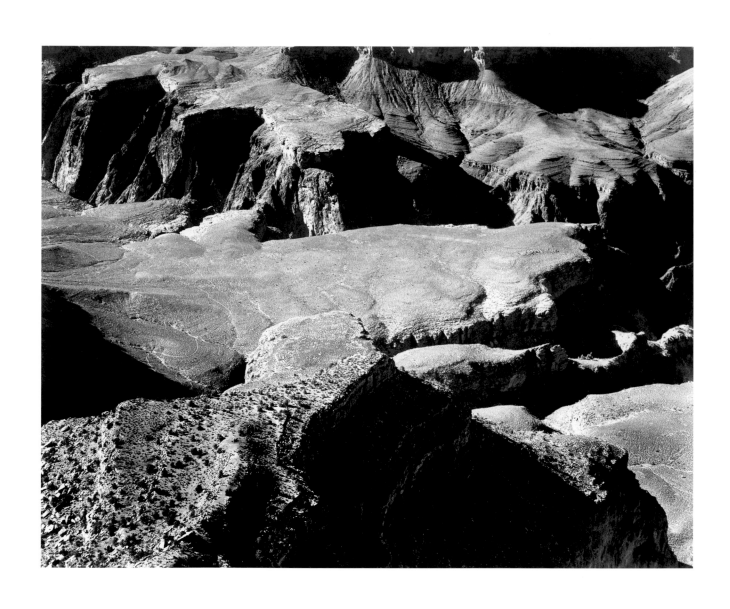

Cliff Formation, Grand Canyon National Park, Arizona, 1942

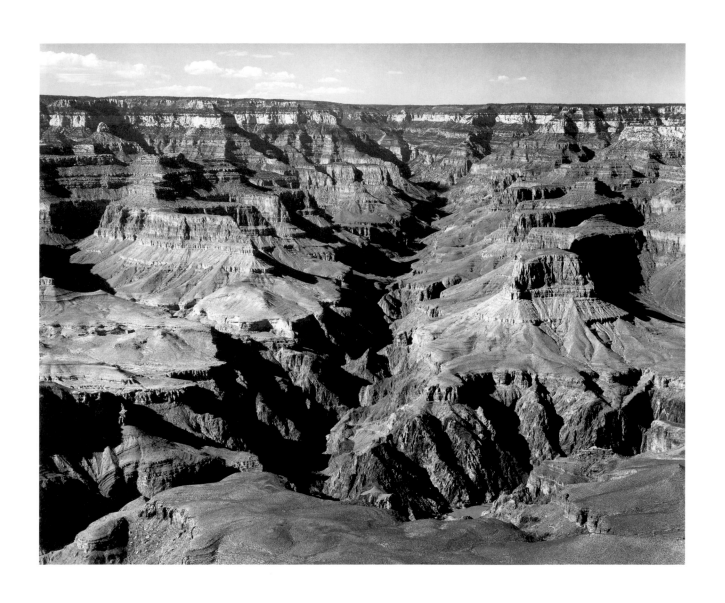

Grand Canyon from Yavapai Point, Bright Angel Canyon, Grand Canyon National Park, Arizona, 1942

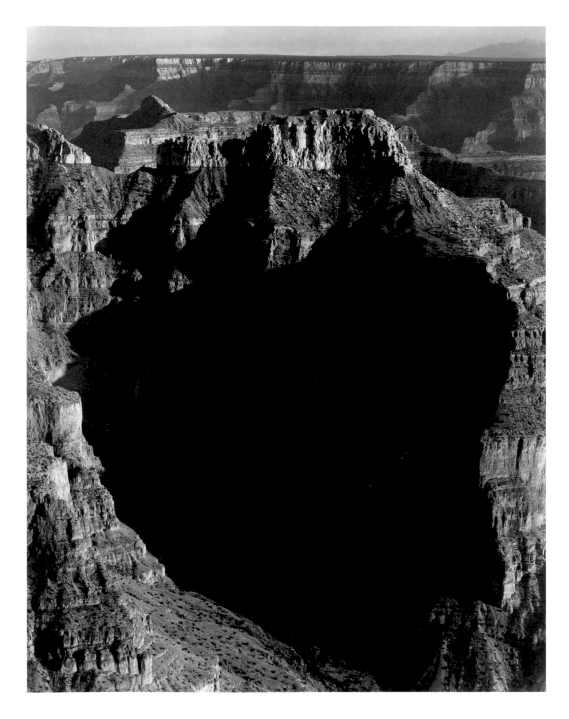

Grand Canyon from Point Sublime, Grand Canyon National Park, Arizona, 1942

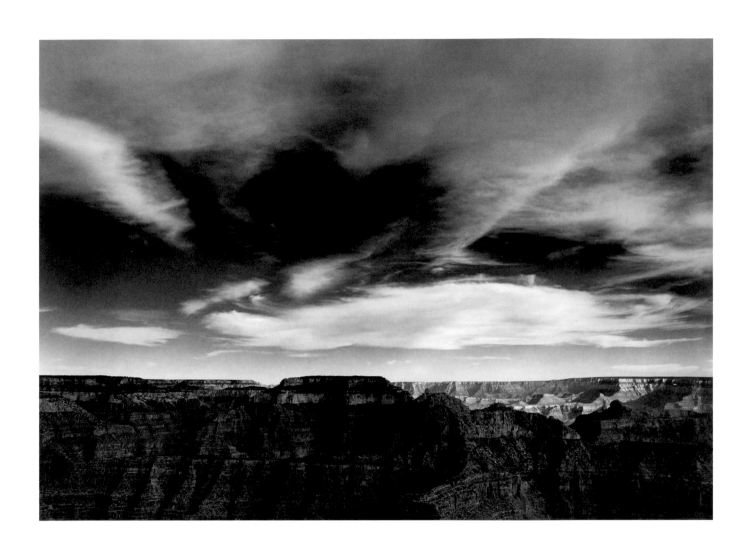

Cliffs and Clouds, Grand Canyon National Park, Arizona, 1942

This is a place to work — and dream.

From a letter to Virginia Adams, April 6, 1928
Santa Fe, New Mexico

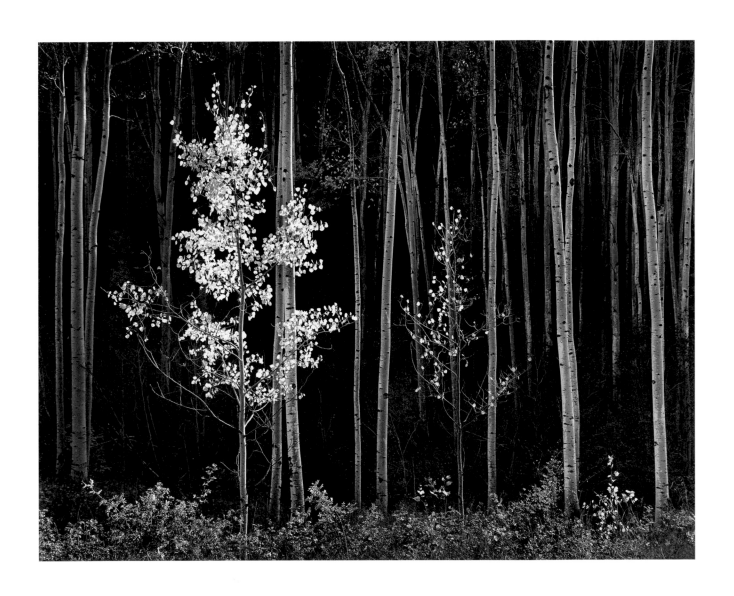

Aspens, Northern New Mexico, 1958

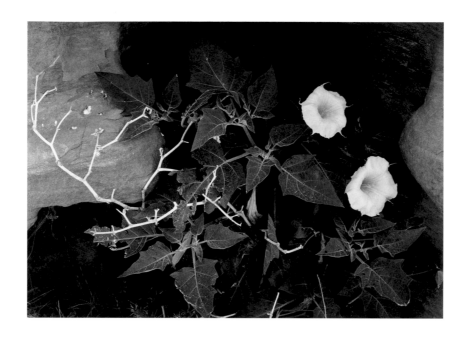

Datura Flower, Canyon de Chelly National Monument, Arizona, 1947

Selected Letters and Writings by Ansel Adams

Ansel Adams made his first trip to the Southwest in May 1927 when he drove Albert Bender and Bertha Pope from San Francisco to Santa Fe, New Mexico. Bender was Adams' first patron, and Adams often acted as his chauffeur. They made the trip in Bender's 1926 Buick over dreadful roads that Adams characterized as "washboards." In his autobiography he described his arrival:

———

Our entrance into Santa Fe was greeted by a dust storm. I went to bed depressed; the bad weather destroying my hopes for a land that had promised many new photographs. The next morning all was diamond bright and clear, and I fell quickly under the spell of the astonishing New Mexican light. The magical transference from dusty wind and heat to sparkling vistas and translucent air was unexpected and felicitous. Summer thunderstorms create the dominant symbolic power of the land; huge ranges of flashing and grumbling clouds with gray curtains of rain clearing both the air and the spirit while nourishing the earth.

Those who have not visited the Southwest will not discover its true qualities in texts or illustrations. Very few artists have caught its spirit; the siren-calls of the theatrical are not favorable to aesthetic integrity. Color photography usually takes advantage of the obvious. Black and white photography fares better, as its inherent abstraction takes the viewer out of the morass of manifest appearance and encourages inspection of the shapes, textures, and the qualities of light characteristic of the region.

Traveling with Albert and me on that first Southwest trip was Bertha Pope, a wealthy, intelligent woman who could not abstain from buying Indian pots, blankets, and other objects to decorate her several houses in the Berkeley area. The three of us spent many wonderful days sightseeing about Santa Fe and meeting many of its exciting citizenry, including the writers Mary Austin and Witter Bynner. The native peoples had responded over the ages to the stark benedictions of earth, water, sky, and sun, giving testament to those four elements in an architecture of noble style and service.

From *Ansel Adams: An Autobiography*

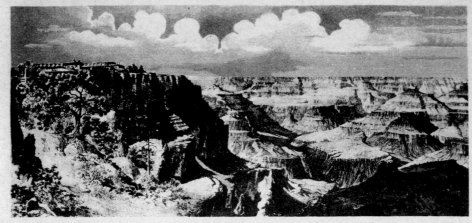

GRAND CANYON NATIONAL PARK ARIZONA.

EL TOVAR
FRED HARVEY.

Thursday —

Dear Ma Pa, and Aunt May

Arrived here last night after 330 mile trip from Gallup
The Canon is too big to get even the slightest impression of in a few hours
We are spending the day here — going to Williams after supper

Everything is well, and as I will be home Sunday night
I will resume my departure until then. How I wish you could
have been with us on this wonderful trip

Hope everything is well with you, We'll be glad to be home
again and at work. This is an experience I shall never forget

Love to all

Adams visited the Southwest for the second time in the spring of 1928. He stayed with Witter (Hal) Bynner in his adobe in Santa Fe. Adams' new wife, Virginia (they were married in January), remained in San Francisco with his family.

To Virginia Adams

Santa Fe, New Mexico
April 4, 1928

My Dearest,

At last — a moment comes when I feel I can write you as I want to — unhurried and not too briefly. It is eight o'clock. Hal [Bynner] is asleep — will be until noon. We were at the Dormans' for dinner and "homed" at 3 A.M. It is strange. I am keeping the pace in the most marvelous way without the least fatigue. I am playing fine and picturing better. Have, I believe, 5 orders for portraits already. And am getting some pottery. But Maria black pottery is surprisingly scarce — I have gathered a lot here in Santa Fe.

The most amazing number of events you can imagine have been crowded into the hours since Sunday night. Yesterday was election day. All the town was dead drunk at 8 A.M. — progressing in tightness as the day went on. Poor Hal's Democratic vote was put in the waste basket instead of the ballot box by the eager Republican management, and — most incredible of all — the present mayor was shot by a drunken Mexican for closing up a gambling den. We drove his daughter to the hospital — not knowing whether he was dead or slightly hurt, discovering the latter. Then the crowd started off to lynch the Mexican. This is some dreamtown, I am sure. The life — the setting — the people — it's all beyond belief. Wait until you see it. How I wish it were *now*. All the friends wait your coming and want us to live here. They have even gone so far as to see what can be done about it. Can you imagine! I am with them — I think you are too. It is hard to say *what* can come out of everything, if we give sufficient thought. . . . I can work here — happily.

My dearest — just because I don't shower you with letters — do not feel I am not thinking of you. For I am, and I am heartily wishing you were present at every moment, and at every place. We *will* do it *soon — damn soon*. I am not rhapsodic this morning — I can't say more than

three little words meaning a very great deal — I love you. Another letter soon, dear, and God bless you. Best wishes to all,

<div align="right">Your own
Ansel</div>

"As when a bird alights at sea
I found you, and you rested me" . . .
 W.B. [Witter Bynner]

P.S. On the way to mail this we were hit by the bootleggers automobile. Nobody hurt except wheel and tank — on the automobile.

To Virginia Adams

<div align="right">Santa Fe, New Mexico
April 6, 1928</div>

My Dearest Virginia,

Today — another long and happy one, with pictures and comradeship, and the beauty of new snow. Hal is a brick — he has done so much for me, and has been the kindest and happiest of friends. A lovely warmth oozes from every corner of his house — accentuated now by the late fall of snow. The town, always beautiful, now doubly so under sparkling white, is in the most important period of its religious year. Many services each day — the streets thronged with all types passing to and from the churches — Mexicans, Indians, old women with quiet kind native faces stumbling across the snow and slush under the leafless trees, mumbling prayers and counting their rosaries under black hoods and shawls. Tomorrow is Good Friday and the processionals and masses will be without number. And, looking over the town and the mesa-hill, the high snowy range — the Range of the Blood of Christ — sleeps in the silent sky. This is a place to work — and dream.

My love to all — and most, as ever, to yourself.

<div align="right">Your own
Ansel</div>

In November 1928 Adams made his third visit to the Southwest, still without Virginia.

Friday

My Dearest

Yesterday Frank Applegate and I took an 80 mile
Drive to a number of townes north of Santa Fe,- Chimayo,
Cordova, Espanola, Santa Cruz. etc. We went into churches
and into homes of Mexicans and Indians and I took fifty
negatives on the waive of entheusiasm. It is all so very
beautiful and picturesque, and the air and mountains and
people are so fine that I am completely "gone"on the land.

There is no use now trying to tell you of the
possibilities that seem to stare me in the face - there is
no one here, nor has there been anyone, who has had the
least luck with pictorial photography on a large scale. I
am amazed at the fresh prospectsthat no nøe has touched.
If I were to work here, the counȥry would give me the same
opportunity that the Sierras gave the first artist that
came to it. I do not understand this opening at this late
day. Hardly anȳthing is more "photographic"than these old
towns and mesas and mountains, and yet nothing has been done.
Mary Austin and Applegate and I have several books planned,
and there seems unlimited things to do.

Mary Austin will sell us a good size lot near her
on the Camino del Monte Sol for three or four hundred dollars
and a handsome adobe house could be build for around $2000.
It would be an easy matter to rent it too, so it would be a
safe investment.

Mary Austin is a peach, and hides a very warm and
generous heart under a stern manner. She wants us to live in
her home while she is at Yale. Reverting to the house we
cou;d build; a high flat (beamed roof) would be the style,
a a great high window could fill one end of the room and
look out directly upon the snow mountains.It would be grand.

ANSEL EASTON ADAMS
129 24TH AVENUE
SAN FRANCISCO·CALIFORNIA
EVERGREEN 5678

Well, we never can tell what will come about. I have a
hunch that when xxxxxx you see this place you will be
even worse bitten than I. Remember, Santa Fe itself is
not the high spot of the land. But here and at Taos, the
peppesentative people of the region are gathered, and
from these centers, they penetrate the great strange
lands of New Mexico. This is undoubtedly the place to
live rather than Taos, which is very inaccessable. And
from here only two days separate us from San Francisco.

The Gormleys are awfully nice to me, and neglect
nothing to make the days and nights comfortable. I must
think up something to do for them. So-far my calendar has
been and is -
Monday night	Gormleys
Tuesday "	Mary Austin
Wednesday "	Hughes
Thursday "	Mary Austin
Friday "	Theresa
Saturday "	Applegate

Sunday and Monday Gawd knows for there are
four invitations.

Poor Hal is very ill; he got up too soon after the Flu
and landed back in bed very hard and quick. He sends his
regards to you and Albert.

Tell Albert that I will write him in a day or so, and that
m I think of him very often. But I start early in the day
and keep going until ten or eleven, and have not much time
to write. The pottery is coming along grand, and I have
four portraits. The trip is a success. I am coming home
with one of Frank Applegates grand watercolours, and a
marvelous prehistoric bowl. It has been a mild session,
thank Gawd, and I have accomplished something. I have had
only one cocktail a day and good bedtime hours.
 I miss you and love you tremendously. Love to Aunty,
and I hope Pop and Ma are getting on grand. Ansel X.

[November 1928]

To Albert Bender

Dear Albert,

So many things have been going on — so many GOOD things that I couldn't begin to put them in a letter. Every day has been an experience of some new place or person. I am convinced this is the greatest place in the world to work. Last spring I stayed with Hal and nearly broke my neck to keep up with him thereby having a devil of a time accomplishing things. But this visit has been just the other way — I have taken several portraits, bought great quantities of pottery, visited many of the marvelous Mexican towns (Cordova, Santa Cruz, Chimayo, and four Pueblos), made good friends with Applegate, Johnson, Nash, Cassidy, and others, and had good long visits with Hal and Mary Austin.

Mary Austin is really a grand person, under her strange stern manner there is a golden heart. She, and Applegate and I are to do a work on the old and modern Mexican life and art in New Mexico. She for the history and folklore, Applegate for the chapters on art, and I am set for the photography. It will take me months, and will be fascinating work. And then the Indian Pueblo book meets her heartiest approval. And she is going to use her influence with the railroad to get me special work. And she has offered us her house and the use of the large studio. It is all too good to be true.

Albert, I have a strong feeling that this land is offering me a tremendous opportunity; no one has really photographed it, and there are unlimited possibilities in many, many ways. And Virginia and I would have an untrodden ground for music as well.

I have satisfied myself to one thing: Santa Fe is much more than the life of Bynner and others would make it. There IS a glorious good time to be had, but there is also a wonderful mood for work, and a great vitality and beauty. Some of the Mexican towns, Cordova, for example, are unbelievably beautiful; always there is an infinitude of pictorial detail. Albert, you did more than you knew when you took me to Santa Fe.

How I have wished you could have been around with me. I have really missed you terribly. Give my love to everybody and if you see Virginia tell her it has been a long week without her.

Yours always,
Ansel

To Virginia Adams

Santa Fe, New Mexico
November 1928

My Dearest,

I have purchased $500 worth of pots, and have about six portraits. I have made lots of grand friends (they're all wild to meet you) and have worked out many plans. It has been a grand trip. . . .

There is a strange quality here; I feel as if I had lived a whole life in this country, so perfectly does it seem to fit me. And I have unlimited energy and great clarity of mind. I want to work hard here — everything is so radiant.

It seems that there is already enough work in view to keep me going very well for a year at least. And that is only scratching the surface. Were I to come here I would be the only one working at photography seriously — I would be a unique institution here. And you and I together would immediately find an important position for us; we would be the only musicians (with a few anemic exceptions) in the entire region, and everyone, music-starved as they are, have implored me to bring you down and stay. Several hundred fine sensitive people hear no music at all, we could do all sorts of things. The plans for what would go on in any studio we could build in San Francisco would apply with more weight here. We could be easily the music center of the place. And the photographic material is simply immense — beyond any imagination. The life, the great mesas and mountains, the strange old-world mood and air, and the marvelous light and clarity — well, it's beyond description. I would not be in the least surprised were our destiny to establish us here.

Mary Austin offered to sell a 50 x 100 foot lot out of her several acres for about 300–400 dollars. It's on the best area of the town — the Camino del Monte Sol — the one pure adobe section of the village, and close to all the most interesting people. . . . I for one am all for a change and a new life, and a new color. What say you? We are really very close to California and the Sierra which I never want to lose or neglect. Well, we can never tell what might occur in a year or so, can we?

I can see or do nothing that I do not wish you were with me. But I know there is always a great unexplainable love that underlies everything between us, and this little absence will only lead to a better and more beautiful life together. So I shall proceed to miss you until Sunday, and will some way manage to pass through three more days without you.

So, until Sunday night, with all the love in the world.

Yours, always,
Ansel E Adams

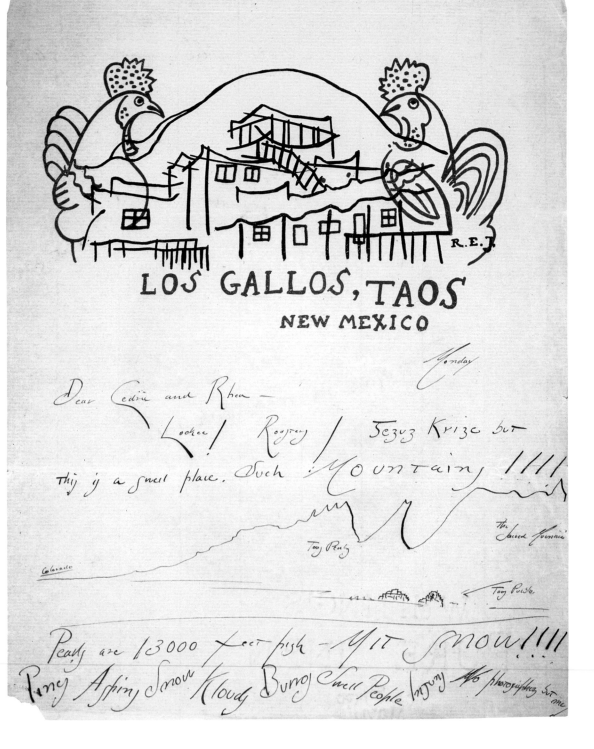

LOS GALLOS, TAOS
NEW MEXICO

Monday

Dear Cedric and Rhea —

Lookee! Rooney / Jezuz Krize but this ij a swell place. Such Mountains !!!!

Colorado

Taoy Peaks

The Sacred Mountain

Taoy Pueblo

Peaks are 13000 feet high — M it Snow !!!!

Piney Ajpiny Snow Kloudy Burroy Swell People Injuny No photographey but me

You gotta see this place before you die.

Excuse my raving

but it is now 12 midnight and I was up at 5 A.M.

Just to keep in touch with you

[signature]

Back in Santa Fe Wednesday.

In March 1929 Ansel and Virginia Adams made an extended visit to the Southwest, spending more than two months in Santa Fe and Taos, New Mexico. While he was there, Adams and Mary Austin decided to work together on a portfolio or book about Taos Pueblo. In the middle of May Adams had his appendix removed in Albuquerque, further lengthening the trip.

THIS SIDE OF CARD IS FOR ADDRESS

Mr. and Mrs. C. H. Adams

Miss May Bray

129 24th Ave.

San Francisco

Califoraia

Barstow
Thursday

Dear Everybody

 We are going strong. Gathering B.E. at Halcyon, we stopped at Santa Barbara over night and proceeded hitherward today. Tomorrow to Arizona. Then to the Grand Canon, Gallup, and Santa Fe.
 I have just acquired a real wild stetson lid for six bucks, that scares even the rabbits.
 Have had no trouble whatever, and do not expect any. Will be carefull, and expect you to do the same. POP, don't go down too early. Will write.
 Love to all from all of us.

Ansel Virginia

To Albert Bender

Santa Fe, New Mexico
March 30, 1929

Dear Albert,

These four days we have been in Santa Fe have been crowded with events — many inconsequential, but all most interesting. Last night we went in quest of the Penitentes; the strange ceremonies of that secret organization is one of the most remarkable phases of New Mexican life. The chants, the processions, the old symbolism of the Crucifixion, held at night in the old adobe villages are unbelievably beautiful. We did not see much last night — missed the proper hour at two places, but traveled nearly a hundred miles in the moonlight in the Rio Grand Valley in quest of the rituals. . . . It is a true old-world religious event, with a glamour that hardly seems possible in this land and age. This, and the Indian dances, are two supreme experiences for the white man; two races, Mexican and Indian, partaking of their most serious religious formalities in a most marvelous setting. I dread to think of you missing all this beauty!

Next Sunday, Ella Young goes with us to San Ildefonso, where the Indians are celebrating a rare Buffalo dance. The following week, I shall get busy. This week of rest was a Godsend.

It may both amuse you and rest your fears to know that the prohibition wolves have descended with drastic effect upon the mild bootlegger lambs of Santa Fe, and the town is almost dry. But the bleating of lost sheep is pitiful to hear, and Hoover is anathema.

Virginia is sleeping off the long night in the open (we got home at 5 A.M.) but I know she sends you her love.

And so do I,

Ansel

I have woke up!!!! Virginia!

April Fourth
1929

Dear Pop,

Today there is a thick black sky and snow
is falling in the hills. Tomorrow it may be a
crystal clear day; the changes of the weather
are always startling. The night we went hunting
the Penitentes the stars were more brilliant
than I have ever seen them - I could really see
the shape of the Orion Nebula. And the sunrise
ofer the Sangre de Christo mountains was most
extraordinary.

Mary Austin gets back in a day or so. We
are enjoying every minute of the time, and the
people are all so good to us that we feel quite
at home. There is unfolding a perspective of
work that seems much much more than I had ever
hoped for. Everyone agrees that I am the only
photographer that has come here really equiped
to handle the country (pardon my vanity). But
it is always to look things square in the face;
if I was not able to manage it, I would freely
admit it. The opportunity is so apparent that I
would be a complete chump to disregard it. I am
certain that New Mexico will keep me half the year
at least (in the future - not this year) and I
shall meet with a great success. The wealth of
material is beyond belief.

I hope Ma is all right now, nothing you
said indicated anything serious, so we have not
worried. But she must not over-do. And you must
not either. How is the Oil flowing? Am thrilled
that the prediction wwas fulfilled. Await all
developments with the greatest interest.

If we do not write everyday, do not think
we have forgotten you. We think of you all
constantly, and hope that some day we can persuade
you to to take a peekaat New Mexico.

Love from us both to all

To Albert Bender

Dear Albert,

We have finally decided on the subject of the portfolio. It will be the Pueblo of Taos. Through Tony Lujan, the Governor of Taos was approached "with velvet" — a Council Meeting was held, and the next morning I was granted permission to photograph the Pueblo. It is a stunning thing — the great pile of adobe five stories high with the Taos Peaks rising in a tremendous way behind. And the Indians are really majestic, wearing, as they do, their blankets as Arabs. I think it will be the most effective subject to work with — and I have every hope of creating something really fine. With Mary Austin writing the text, and [John] Nash printing the book, I have a grand task to come up to it with the pictures. But I am sure I can do it. Dear Albert — look what you started when you brought me to Santa Fe!

Your letters have come as bright lights from California — I am really homesick for you all, but it will not be long now before we are together again! I should be home about the end of June. I have four weeks with the Sierra Club, and then will be set firm and adamant in the splendid city of San Francisco for all fall and winter.

Gawd bless you, Albert — for a million glorious things.

Love from us both — always,
Ansel

———

Taos, New Mexico
April 1929

Dear Albert,

For two days I have been in bed nursing a tummy-ache caused by a touch of intestinal flu. Everyone here has had it. I shall be O.K. in a day or so. They have a good doctor here in Taos who prescribes Castor Oil and Pluto Water in enormous quantity. It works!

Regret pencil — but am writing in bed and don't dare put ink bottle on covers.

Will be up tomorrow, and busy once more with camera.

Georgia O'Keeffe — wife of Stieglitz — and Mrs. Strand — wife of Paul Strand — N.Y. photographer — are staying here with Lujan's. We have some great conversations.

Virginia and I send you oodles of love — all there is is not too much for you.

Ansel

St. Joseph's Hospital
Albuquerque, New Mexico
May 1929

Dear Albert,

I wanted just to say hello and tell you that just knowing you would brighten up the most tragic situation. Mine is anything but that, especially today, for I expect to get up and out in the air, as soon as the doctor looks me over. I have paraded all the halls of the building, and invaded all the porches, and kitchens, and yearn for the cool tree-shaded streets of Albuquerque as a stepping stone to Santa Fe. I warn you that I observe the embryonic pangs of a huge appetite which should mature by the time we reach home. Even now I call lustfully for coffee and put aside vast loads of creamed chicken.

Here comes the doctor — good-bye and much love from us both.

Ansel

To Charles and Olive Adams and Aunt Mary Bray

Santa Fe, New Mexico
June 7, 1929

Dear Pa, Ma, and Aunt Mary,

There is nothing new to tell you about except to thank you for the letters and all else. I am getting along grand and am photographing santos and driving the car around town and eating anawfullot and putting on weight (seven pounds since the hospital was discarded) and everybody says I look better than I ever did and I really believe I do feel better than I ever did even if my tummy is a bit stiff and I am still plastered with adhesive which I get tight before I eat and then after I eat it gets tighter and I feel just like I was a wagon wheel with a tire shrunk on me and I know what it must be to get embraced by a Boa-constrictor but outside of that little inconvenience I am just grand and got lots of wind for I wrote all the above on one breath. There!

We will leave I guess about the fifteenth and go to Taos for a few days and then see Colorado and Utah and Nevada and end up at Yosemite to finish the Ahwahnee book. Will be home about the end of the month.

Love to all from us both,
Ansel

In the fall of 1929 Adams returned for his fifth trip to the Southwest, to continue work on Taos Pueblo.

ANSEL EASTON ADAMS
129 TWENTY-FOURTH AVENUE
SAN FRANCISCO, CALIFORNIA

Monday Morning

Dear Everybody,

 Arrived safe last night and am
comfortably situated at the Applegates.

 Eventful trip: Drive Rod broke
on Engine near Bakersfield,-
Hot Box and flat wheels near
Mojave,-
Stage busts spring twelve miles
from Santa Fe, and delays two
hours.
Teeth busted at lunch room.

Otherwise am just fine.

 Will write soon

 Love to all

In the summer of 1930 Adams once again traveled to the Southwest. During this trip, he met photographer Paul Strand for the first time.

To Virginia Adams

Santa Fe, New Mexico
[Late August 1930]

My Dearest,

I thought I would be able to write you yesterday, but Mary Austin asked me to supper and I stayed quite late. And I was working in the Old Museum the entire day.

Everything is going splendidly. I accomplished a lot at Taos, in spite of Mabel, and made some very good friends. Paul and Becky Strand are in one of Mabel's houses. The transformation in Becky from last year is amazing — she was terribly nice to me and we had a lot of fun. Paul Strand is a peach. O'Keeffe was there also, breezing around in a rather cool way — but not as frigid as last year. They hardly ever see Mabel, and the entire situation is too funny for words. Will tell you. . . .

But the one gorgeous thing in Taos is the painter, [John] Marin. We had a morning with him. His work is a revelation. They are all acknowledging that Marin is doing things in water-color that puts him at the top of American painters. Intuitively, I feel something very great indeed about the man, and, as all of that type, he is about as simple as a baby, and terribly funny. It was refreshing to punctuate sophisticated arguments with a few hours with Marin.

In the last two weeks something has clicked inside me and I have an entirely new perspective on many things concerning my work. I can't write it out — I just will have to do it.

. . . Tell Pop and Ma and Aunt Mary that I think of them a lot, but have not enough to say to write them about. But I wish you could all come down, just to see the gardens. Much love to everybody.

Just oodles of love to you. I will be very glad indeed to get close to you again.

Yours lonesomely,
Ansel

Excerpt from a rough draft for Adams' autobiography, July 19, 1981:

When I first met Strand in Taos, New Mexico in 1930 he was in buoyant spirit (for him). He was with Becky, his first wife — a serene and beautiful woman — and the summer sunlight and thunderclouds were never more inspiring. He had made many negatives in the previous month — he had no prints of them, nor had he brought prints from New York. I came to see him in the little detached adobe apartment Mabel Lujan had given the Strands for the summer. I had met them, together with Georgia O'Keeffe, at a dinner with Mabel Lujan the previous night. He was quite silent and distant during dinner. He inquired about my project — the Taos Pueblo book with Mary Austin — and asked me to visit him. I inquired when it would be convenient and he said, "Tomorrow afternoon — about the middle of the afternoon. I must photograph after four." This disturbed some appointments at the Pueblo which Tony had kindly arranged for me but I obeyed intuitive feelings and appeared dutifully at three o'clock. Strand greeted me warmly (much more relaxed than on the previous night). He found a white piece of paper which he set in the sun streaming through a south window. He placed me squarely before the paper and opened a box of 4x5-inch negatives which he handed to me, holding them by the short edges so that I could receive and hold them by the long edges before the bright paper. He admonished me, "Hold them *only* by the edges." Most were horizontal images and some were presented upside-down; I had to do a bit of twisting about to properly see them.

They were glorious negatives! Full, "luminous" shadow areas and strong high values in which were preserved subtle passages of tone. The composition of all of them was extraordinary; perfect, uncluttered edges and beautifully distributed shapes (which I realized that he had "seen" and interpreted as forms — simple, yet of great power). Between three and four o'clock in that afternoon on that eventful day I made up my mind: I *was* going to be a photographer.

———

In November 1936 Adams traveled to New York to see his exhibition at Alfred Stieglitz's gallery, An American Place. On his return trip he stopped in New Mexico to photograph the Carlsbad Caverns, where he wrote to Patsy English, who was his photographic assistant at the time.

To Patsy English

My Dear Patsy,

This is the longest week I have ever had in my life!! Southern New Mexico — Desert — Desert, DESERT. And a cold wind is blowing and the sky is gray with furious clouds. I feel like an atom somewhere off in space between the moon and Spica!!

I am gradually becoming impressed with the Carlsbad Caverns; but they are so strange and deep in the earth that I can never feel about them as I do with things in the sun — rocks, trees, you, surf and fog. The photographic problems are terrific; I start with a basic exposure of about ten minutes. . . . I then boost up the image and "drama" with photoflash. Some of the forms are beyond description for sheer beauty; textures and substances are not so important as the formations are white and cream-colored in the main.

Twice a day I ride down in the elevator (just like an office building) for 750 feet, and then walk a mile through the caverns to the selected spot. I have not yet completed the smaller rooms — will tackle the Big Room (about two miles around) tomorrow and Friday.

In many ways the Carlsbad Caverns are symbolic of my life; beautiful and exquisite things that exist only in the light of the moment — the light that comes from the mind and the heart. If the light were to go out — there is no other way to see. These things must be caught when they can — worked to perfection when they can. Then something is crystallized that may be worthwhile. I am sorry I am not writing this adequately — for I feel it more intensely than I have ever felt anything before. But a few things reassure me — the great arc of the star, the irrevocable facts of my life, and such things as the letter you wrote me to Chicago. I thank you again and again. If this country permitted I would make you a photograph that would say it better than these mussy words.

Mary Austin told me once that "you have to fight — fight with all that you have — to climb the steep hills and say what you have to say and to say it beautifully, and with meaning." I am just beginning to fight, Patsy, and I have formidable opponents. Advertising, the mad scramble and rush, the petty details, the foolish pictures to fool the public — to make them think as the advertisers want them to think. I would rather live on the ground, freeze in winter, and suffer in summer heat, than give in to it willingly — and yet I have to remember I am a human being — a cog in a wheel that must turn incessantly. The great problem — if I can solve it, then I will be the real artist, is to be both the cog and the creator. Help me to be both. I know I am not wrong in my evaluation of you.

Ansel

GHOST RANCH
ABIQUIU, NEW MEXICO
Telegraph: Espanola, N. M.

Saturday

Dear Virginia,

There is no use in my trying to describe this place;
it beats anything I have seen anywhere for complete beauty.

I am very sorry that you are not here. We _must_ come
sometime.

Georgia O'Keffee is busy painting, and I expect a
grand harvest of pictures.

The plans for the trip are not yet fully determined
except that we will start from here a week from Monday and spend
most of the time in the Navajo country. I suppose I will be at the
Grand Canyon about the 8th of October.

The pictures in the booklet are not good; the gardens
are beautiful. There is a lusciousness here that I have seldom seen
in New Mexico.

The clouds are coming up and I feel the itch to click
the shutters.

I will write soon. Hope Ron and the kids and Katherine
the Mrs. Schlanze and the car got back to Yosemite in good order.

Will try to make some good pictures for you!

loads of love to all

expecially to you

I sent the family a bunch of Indian Corn from Santa Fe. Will try to
find something nice for you and the kids.

love

In the fall of 1937 David McAlpin, Adams' patron and friend, visited the Southwest. He made it possible for Adams to join Georgia O'Keeffe at her home in Abiquiu, along with McAlpin and his cousin Godfrey Rockefeller and Godfrey's wife.

To Alfred Stieglitz

Ghost Ranch
Abiquiu, New Mexico
September 21, 1937

Dear Stieglitz,

By a miraculous sequence of circumstances and the kindness of David McAlpin I am in New Mexico with three cameras, a case of films, a big appetite, and a vigorous feeling of accomplishment.

It is all very beautiful and magical here — a quality which cannot be described. You have to live it and breathe it, let the sun bake it into you. The skies and land are so enormous, and the detail so precise and exquisite that wherever you are you are isolated in a glowing world between the macro and the micro, where everything is sidewise under you and over you, and the clocks stopped long ago.

O'Keeffe is supremely happy and painting, as usual, supremely swell things. When she goes out riding with a blue shirt, black vest and black hat, and scampers around against the thunderclouds — I tell you, it's something — all that is needed to complete the picture is to have you out in the gardens at six A.M. in your green cape. I am quite certain you would like it here. But it is a long way from New York, especially for a person with your kind of schedules to fill.

I think I am getting some very good things — quite different, I believe. I like to think of my present stuff as more subtle, more lifting-up-the-lid, if you know what I mean. I did some new things in the Owens Valley in California that I want you to see; I hope I will have things from here that I would want you to see, too.

Nothing important has happened to me, except a glimmering of wondering what it is all about — work, and living in general. Perhaps I am on the edge of making a really good photograph. I hope so. I have a growing awareness of the insufficiencies of my own work. I hope it's a good sign.

O'Keeffe tells me you are in good shape and have had a bearable summer. I am glad — you

deserve the best of good health and peace of mind. A season such as yours in New York must be a very wearing thing for the strongest person.

It's trite to say it, but I wish you were here. Gawd knows when I will get to New York again — but I hope it will not be in the too distant future. McAlpin sends you his very best. He is a good man, with a precious mixture of caution and enthusiasm.

All good wishes to you,
Ansel Adams

———

Yosemite National Park, California
January 8, 1938

Dear Stieglitz,

I am beginning to make good prints of the SW pictures. If you saw the proofs I sent Dave you probably have a rather low opinion of the set, because the proofs were very bad. But — I am convinced that the effect of my photography depends largely on tonal values — more so than in most photographs. Weston's work, for instance, delivers its impact largely through simple and spectacular form. But perhaps you also saw the one good print I have sent him to date — the "Old Woman of Coyote." I feel pretty good about that.

Would like nothing better than to see the O'Keeffe show — and all of you along with it.

All good wishes,
Ansel

Editor's note: Adams refers here to the photograph Spanish-American Woman, near Chimayo [page 19].

———

In 1941 Adams started a series of photographs of national parks and monuments sponsored by the Department of the Interior. Their intent was to use Adams' photographs to produce murals for the Department's large, new Washington offices. Adams made his first trip in October 1941, visiting many sites in the Southwest. His work was cut short in 1942 by the entry of the United States in World War II, and although Adams made one more photographic trip in 1942, his photographs were never made into murals.

To Beaumont and Nancy Newhall

<div align="right">

Mesa Verde National Park, Colorado
October 26, 1941

</div>

Dear Beaumont and Nancy,

 We have had a spectacular and dangerous trip. All went well through Death Valley, Boulder Dam, Zion, North Rim, South Rim, Cameron. Then we spent the night on Walpi Mesa, proceeded to Chinle, and had two spectacular stormy days at Canyon de Chelly. I photographed the White House Ruins from almost the identical spot and time of the O'Sullivan picture!! Can't wait until I see what I got. Then our troubles began. They have had the worst rainy season in twenty-five years and the roads through the Indian Country are unbelievable. The road from Chinle to Kayenta was so terrible that it took us fifteen hours to go sixty miles; then we ended up at midnight flat on our chassis in the worst mud hole you ever saw — with lightning and thunder and rain roaring on us. We slept in the car that night and worked from 5 A.M. till noon getting the old bus rolling again. Then, after Kayenta and Monument Valley, we struck a very tough road in Utah — Snake Canyon is just the rocky bottom of a rugged gorge and is also the road, and that is something fierce; you feel as if the car is to turn over any time or get impaled on rocks. Then, in short order, we had the terrible hill — so steep a car can just make it in low. It was muddy; we could not keep on the crowns — chiefly because I did not want to drive closer than two feet from the precipitous edge on the right — and four times we slid off into the mud ruts on the inside. That meant backing down over 1000 feet of road and starting off again. Finally, we unloaded the car — 1500 pounds of stuff, finally made the grade and then had to carry all the stuff up by hand. After recuperating from that little exertion, we proceeded a few miles and encountered the Butler Wash. It was running fifteen inches deep, so we thought it was safe. I set the car in low and proceeded to barge through as I have many such affairs. When the front wheels touched the far bank the motor stopped — water thrown on the block by the fan belt. I should have removed it first. Well, there we were with the backside of the car actually under water. In a moment of panic I decided to reverse and get out of it all; I could not budge the car ahead after getting it started because the rear wheels had ground a hole and no advance was possible. I put it in reverse, gunned it, got half way across, and the entire ignition passed out! Here I was, with the muddy water running over the floor board and within two inches of cameras and films in the back. A storm was coming up; things looked black indeed because those washes can rise five feet in fifteen minutes. We stripped and moved everything out of the car onto a high bank. It was seven miles from the nearest town, Cedric Wright started out to walk for help while I finished unpacking and covering stuff against the coming rain. The water was coming up, and the car looked done for. Cedric met a car about

three miles out, and they tried to pull us out. No luck; practically burned out their own clutch. Water still sneaking up; storm looking bad. Car took me to next town — Bluff, Utah — and I got the state road man to come out and try to save us. Even with a large truck, the mud, water, soft wet sand, etc. made it necessary to remove us by a system of shattering jerks. We just did get the car out; the storm broke, and the wash went up. We were so completely lucky — timed almost to ten minutes! We then had a tough tow for seven miles, and spent the night getting mud and sand out of brakes, axles, etc. Got to Monticello and had to have the clutch done over. Breathed a vast sigh of relief when we struck the pavement in Colorado. Never such a trip. We have only 4000 more miles to go!!

So much for that. . . .

<div align="right">Affectionately yours,
Ansel A.</div>

In 1946 Adams received a grant from the Guggenheim Foundation to finish the work he had begun in 1941–42 photographing the national parks and monuments. He embarked on a tour through the Southwest beginning in Death Valley.

To Minor White

<div align="right">Twenty-nine Palms, California
[1947]</div>

Dear Minor,

I had not realized how far I had drifted from the "creative condition." But I have exposed eight dozen films and think I have some of the best stuff I have ever done. Teach, it's marvelous! Death Valley is SOMETHING! No use talking about it — it's just a tremendous nest of photographic opportunity. Interesting to recognize many of Edward's [Weston] pets, and also interesting to figure how I would do them my way.

Looking back on the immediate past, I wonder how I avoided blowing up, dismembering myself emotionally and physically, with the pressure of work I brought upon myself. NEVER AGAIN! The big wide horizon seems to be actually opening up in a clear, potent way.

The earth looks good indeed; the forms of nature — once they are integrated on the magic rectangle of the film — satisfy me completely.

<div align="right">As ever,
Ansel</div>

List of Plates